SALFORD
THROUGH TIME
Paul Hindle

AMBERLEY PUBLISHING

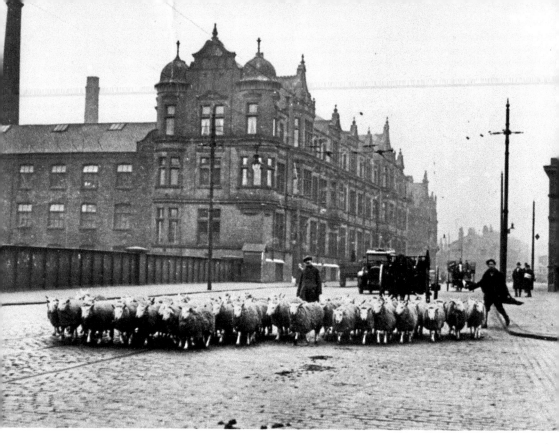

Sheep being driven across Regent Road Bridge in the 1920s – this is now the busy A57 linking the Mancunian Way to the M62.

First published 2014

Amberley Publishing
The Hill, Stroud, Gloucestershire, GL5 4EP
www.amberley-books.com

Copyright © Paul Hindle, 2014

The right of Paul Hindle to be identified as the Author
of this work has been asserted in accordance with the
Copyrights, Designs and Patents Act 1988.

ISBN 978 1 4456 3611 5 (print)
ISBN 978 1 4456 3639 9 (ebook)

British Library Cataloguing in Publication Data.
A catalogue record for this book is available from the
British Library.

Typesetting by Amberley Publishing.
Printed in Great Britain.

Introduction

The first written record of Salford is in the Domesday Book in 1086; it had a market by 1228 and obtained a borough charter in 1230. Sacred Trinity church was founded in 1634. It was not until the late eighteenth century that urban growth began in earnest. This was largely enabled by improvements in transport: the River Irwell was made navigable from 1721; the first turnpikes (to Bolton, Duxbury, Wigan and Warrington) were created in 1753; the Bridgewater Canal was begun in 1759; the Manchester Bolton & Bury Canal was opened in 1797 and the Manchester & Bolton Railway was opened in 1838. Other notable dates were the openings of New Bailey Prison (1790), the first gasworks (1820), Cross Street cattle market (1837), Peel Park (1846), the Roman Catholic Cathedral (1848), the free library and museum (1850), the first tramways (1877), Hope Hospital (1882), Manchester Ship Canal and Docks (1894) and the Technical Institute (1896). Salford became a parliamentary borough in 1832, a municipal borough in 1844, a county borough in 1889 and a city in 1926.

But mid-nineteenth-century Salford was not a pleasant place. Friedrich Engels, writing in 1845, described the town as 'unhealthy, dirty and dilapidated ... The whole of Salford consists of courts and lanes which are so narrow ... Salford is dirtier than Manchester ... I am sure that the narrow side streets and courts of Chapel Street, Greengate and Gravel Lane have never once been cleaned since they were built.' Salford's poor reputation lived on into the 1960s when large-scale redevelopment began, demolishing vast areas of slum housing and culminating in the development of Salford Quays.

Salford has often been overshadowed by its larger neighbour, Manchester, but all three 'Manchester' racecourses were in Salford, as were 'Manchester' Exchange station and most of 'Manchester' Docks. As far back as the 1790s, the Manchester Bolton & Bury Canal actually began in Salford and never entered Manchester. Even recently, the BBC kept announcing that it was moving to new premises in Manchester, rather than to the new Media City in Salford Quays.

It was not possible to include all of Salford in one volume, even if just using the city limits before the 1974 boundary changes. Instead, the book concentrates on the city centre, plus Broughton and Kersal. This book is structured around three routes, which can be followed on foot, by bicycle or by car. The first starts in the historic centre, and then follows Chapel Street and the Crescent to Broad Street and Eccles Old Road, with diversions to Peel Park and Buile Hill Park. The second route, beginning on page 61, goes from Lower to Higher Broughton, continuing as far as Kersal. The third route, beginning on page 82, follows the often ignored Manchester Bolton & Bury Canal from the River Irwell as far as Agecroft. There is a companion volume in this series devoted to the whole canal – *Manchester Bolton & Bury Canal Through Time*.

Route One

Buile Hill Park - **Eccles Old Road** – Bolton Road
Seedley Park ↑
 Pendleton
 ↑
Cross Lane - **Broad Street**
 ↑ Peel Park
Fire Station - **The Crescent** – Peel Building
 ↑ Art Gallery
Salford Royal Hospital
↑
St Philip's Church
↑
Salford Cathedral
↑
Bexley Square (Town Hall)
↑
Salford Station
↑
Sacred Trinity Church
Flat Iron Market
↑
Chapel Street
↑
Victoria Bus Station
↑
Exchange Station

Route Two

Kersal Cell ← St Paul's Church ← Kersal Bar
 ↑
The Cliff ← Great Clowes St → Bury New Road
 ↑
Castle Irwell → Albert Park
↑
Tram Depot
↑
Lower Broughton Road ← Great Clowes St

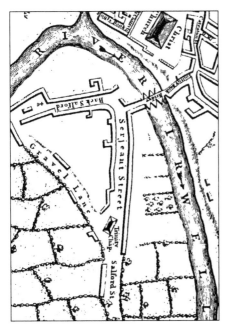

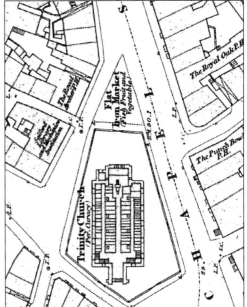

Salford Maps

The map (*above left*) shows Salford around 1650; it consists of a triangle of streets, focusing on Trinity chapel, and a bridge crosses the River Irwell to Manchester and its prominent Christ Church. The map (*above right*) is from the Ordnance Survey 5-foot plan surveyed in the mid-1840s. It shows Trinity church (with its internal layout) and the Flat Iron Market (selling fish, fruit and vegetables), whose name is obvious from its shape. The large map (*right*) was surveyed by William Green in 1787–93, and shows an enlarged town, though the built-up area, largely along Chapel Street, barely reached the Crescent. Three bridges connect Salford with Manchester, and the New Bailey Prison (opened in 1790) is an obvious feature.

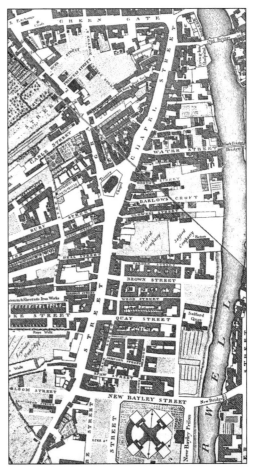

Route One

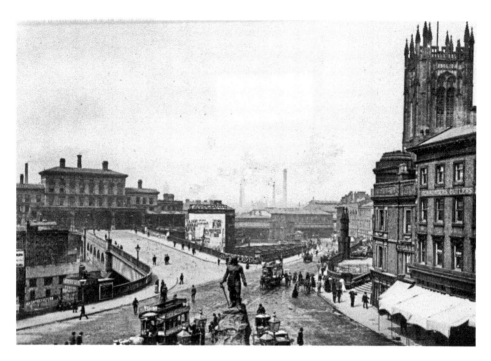

Exchange Station

The railway line linking Salford and Manchester Victoria stations was opened in 1844, but Victoria became so congested that Manchester Exchange station was opened by the London & North Western Railway (LNWR) in 1884. It was named Manchester Exchange despite most of it being in Salford. Manchester Cathedral is on the right, and a wide approach ramp led across the River Irwell to the station. A second approach led down to Chapel Street.

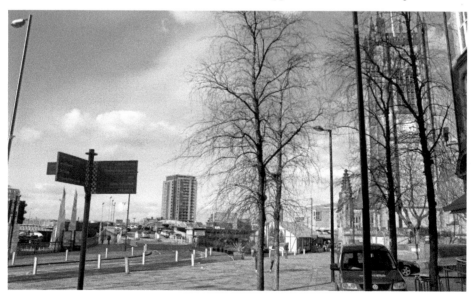

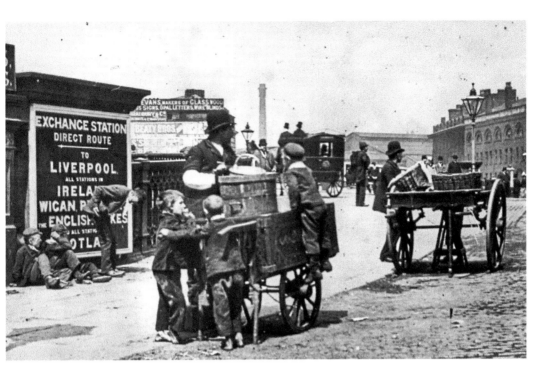

Exchange Station Approach

The sign indicates the great variety of destinations served by the station. From 1929, its platform 3 was linked to Victoria's platform 11 to create the longest platform in Europe, able to accommodate three trains. The station closed in 1969 and is now largely used as a car park. Something is clearly distracting the vendors in the upper picture.

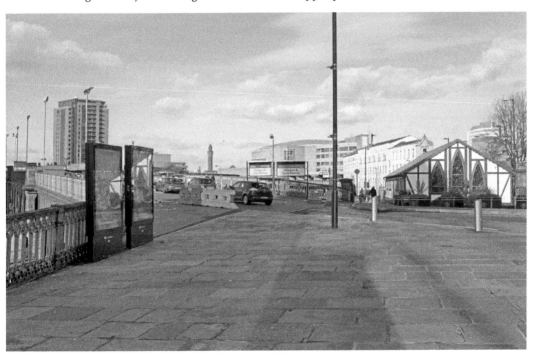

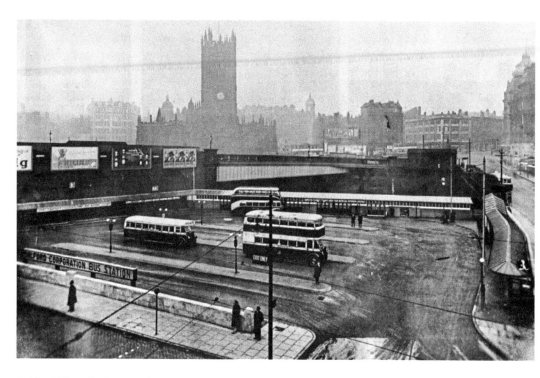

Salford Victoria Bus Station

This area originally had industrial premises and a public house. The bus station was opened in 1937, and the picture above was taken soon after; Manchester Cathedral looms behind. The bus station closed in 1988 and was a car park for many years. It was reused by buses in 2005, while the new Shudehill interchange was being built. There is a new footbridge across the River Irwell.

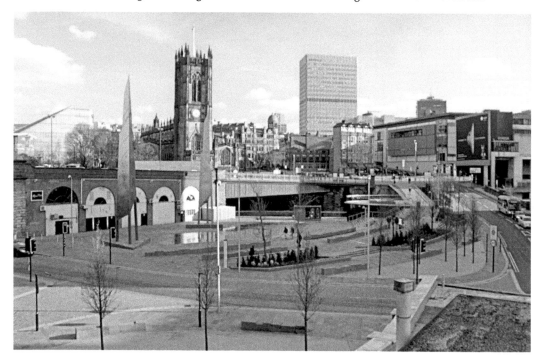

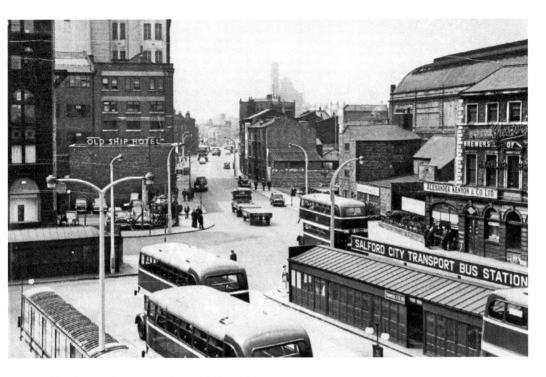

Salford Victoria Bus Station and Chapel Street
The bus station site is now an open public space with a water feature, forming the first part of the Greengate Embankment regeneration area, which will also include the former Exchange station site and land beyond. Comparing the two pictures, it is clear how few buildings have survived.

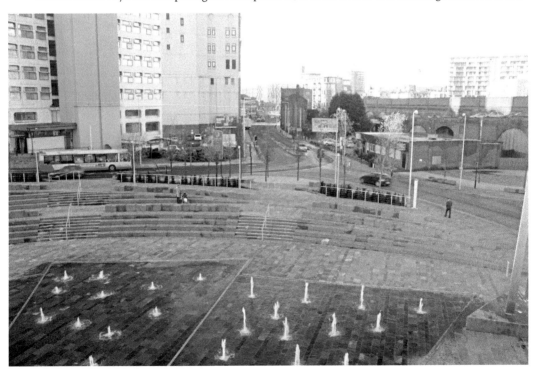

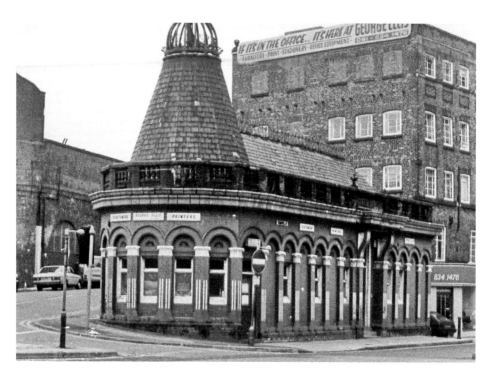

Old Police Station

The police station replaced an earlier one located in Harding's buildings, just behind; the old station was lost in the construction of the Salford approach ramp to Exchange station. This building was later was used as a tram ticket office and then as part of a printworks; several firms now use it.

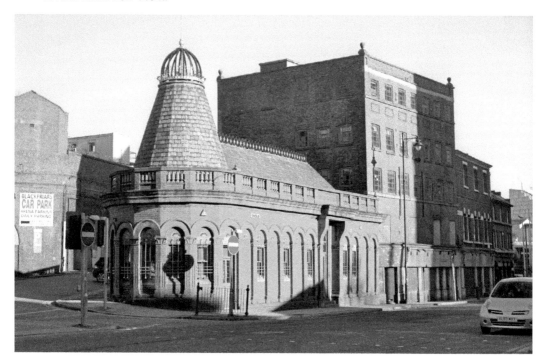

Sacred Trinity Church
This is Salford's oldest church, completed in 1635; as a chapel it gave its name to the street. It was originally built with funds provided by Sir Humphrey Booth. It became an independent parish church in 1650, and John Wesley preached here in 1733. The church was rebuilt in 1752/53, restored in 1877 and altered internally in the 1980s.

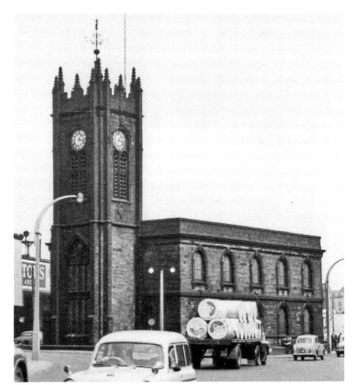

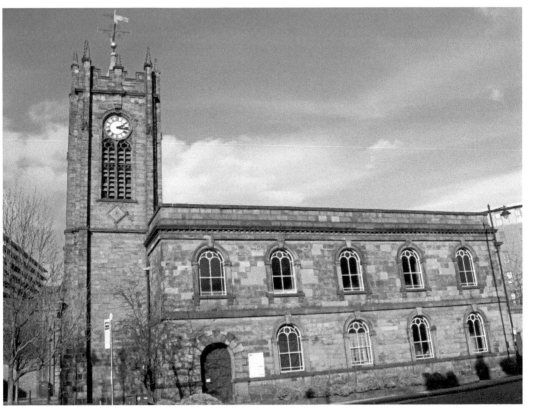

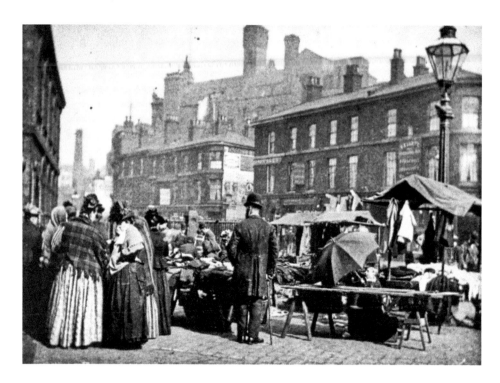

Flat Iron Market

The market was shown on the 1840 Ordnance Survey map as selling fish, fruit and vegetables, though it later specialised in second-hand clothing and books. It got its name from the distinctive shape of the site (*see map on page 5*). The modern view is almost identical to the 1896 picture. The market closed here in 1939, and the stalls moved to Cross Lane market.

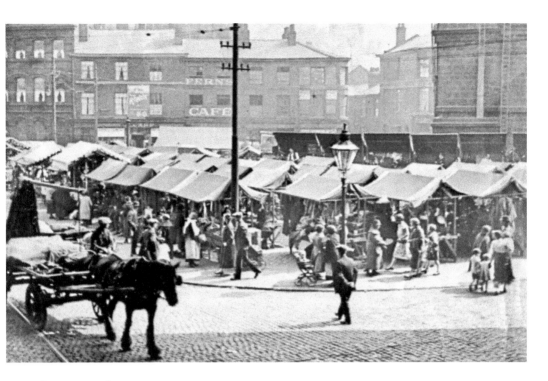

Flat Iron Market

The market overflowed onto the space behind the church, and is shown on the 1915 Ordnance Survey 25-inch map as Trinity Market. The upper picture was taken in 1925. The Flat Iron conservation area includes the church, two public houses and two other buildings; it extends along the right-hand side of Blackfriars Street to the River Irwell.

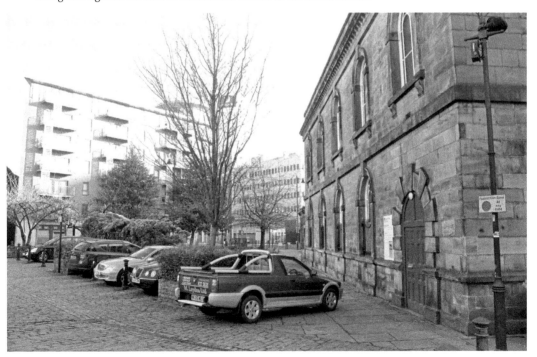

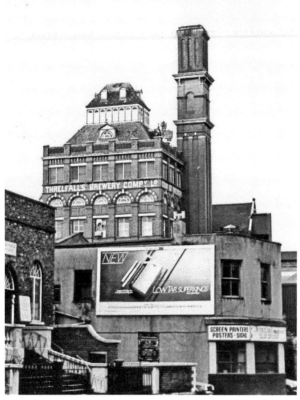

Cook Street Brewery

This impressive brewery was built by Threlfalls in 1896. It merged with Chesters in 1961, was taken over by Whitbread in 1967 and was closed in 1999. It was the largest brewery in the North West of England. It has now been converted into an 'urban business village' called the Deva Centre.

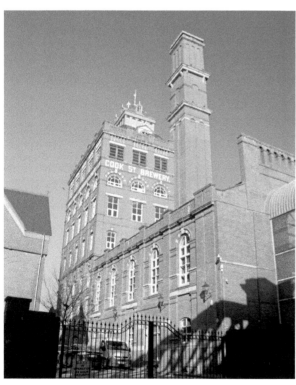

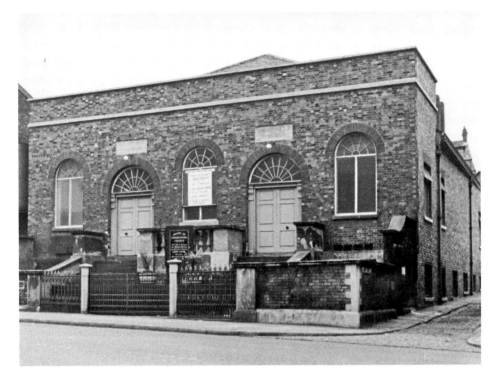

Chapel Street Chapel

The Independent Congregational chapel, seen above, was built in 1819; the upper picture was taken in 1962. Its full name is now Chapel Street and Hope United Reformed church.

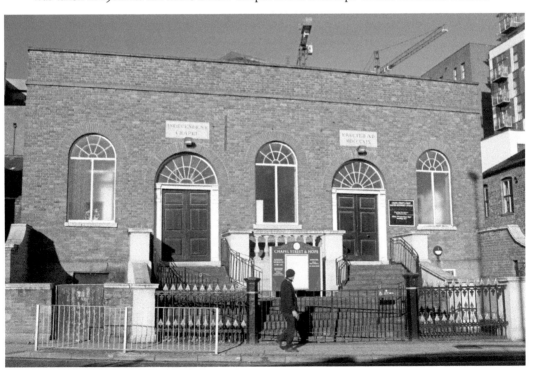

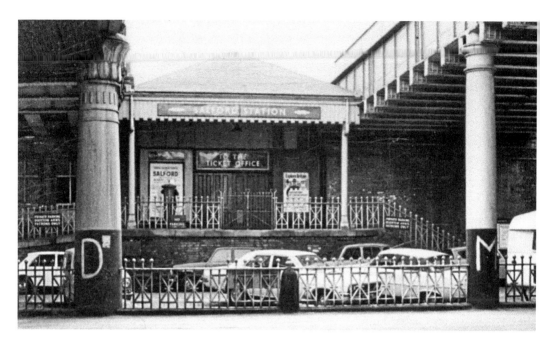

Salford Station

Salford Central station was the original terminus of the Manchester & Bolton Railway, built by the Manchester Bolton & Bury Canal Navigation and Railway Company and opened in 1838. The line was extended to Manchester Victoria in 1844. The three bridges that span New Bailey Street are all different, each with different style columns, and are listed structures. New Bailey Prison (1790–1860) formerly stood between the railway and the river.

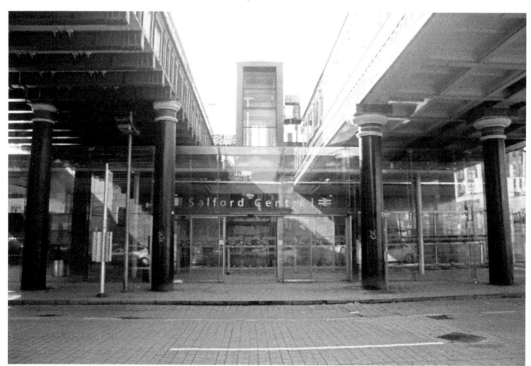

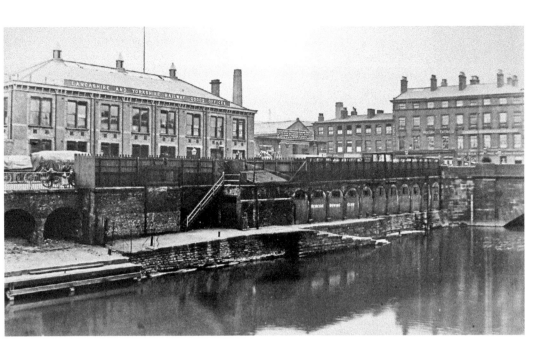

Albert Bridge
Albert Bridge was opened in 1844, connecting New Bailey Street to Bridge Street. The Lancashire & Yorkshire Railway goods offices have long since disappeared. The arches, once partly occupied by the Nemesis Rowing Club, were home to the Mark Addy restaurant from 1981 until its closure in 2014 – it may, however, be reopening. Mark Addy (1838–90) was known as the 'Salford Hero' and was awarded the Victoria Cross for saving many people from drowning in the River Irwell.

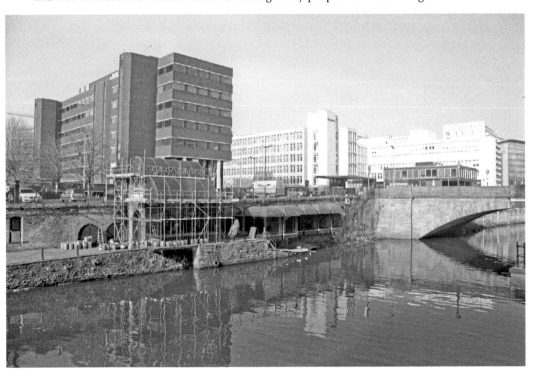

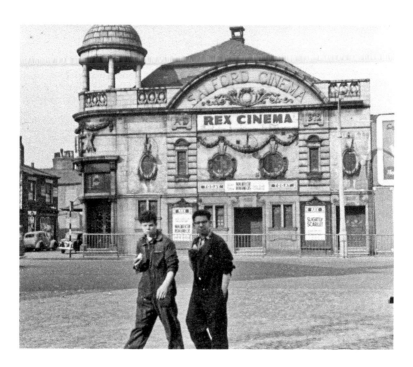

Salford Cinema

This was originally a Scottish Presbyterian church, built in 1846, with a tall spire. The spire was taken down and a new frontage added (including a Moorish cupola) when it became the Salford Cinema in 1912. It became the Rex Cinema in 1933, but closed in 1959 and was then used as a bingo hall from 1967. The upper picture was taken in 1957. For over twenty years, it has been the New Harvest multicultural church.

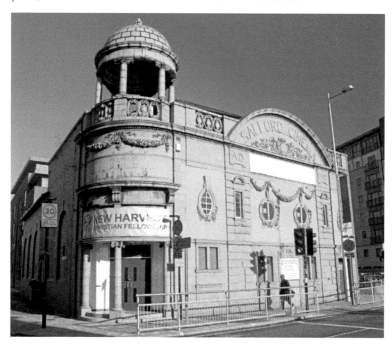

Chapel Street
The picture to the right was taken in 1963. Chapel Street is now in the process of being regenerated; a 20 mph speed limit has already been introduced, with new street lighting and surfacing. The aim is to make it an attractive city high street connecting Salford University with Manchester city centre, with a mixture of housing, shops and businesses.

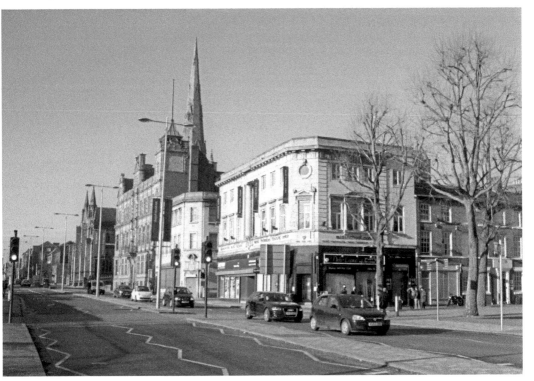

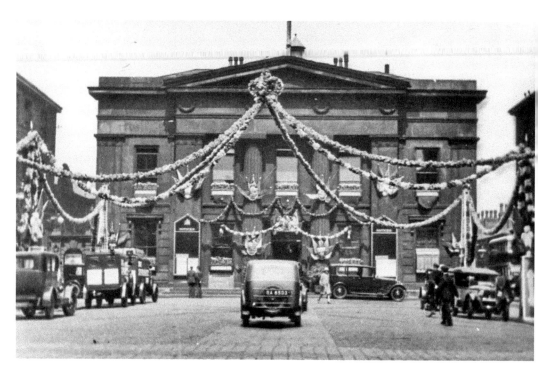

Salford Town Hall

The town hall was built in 1825–27, and stands in Bexley Square, which was named after Lord Bexley, then Lord Lieutenant of Lancashire. At first it had a market hall on the ground floor. It was the scene of the Battle of Bexley Square in 1931, a protest against means testing. The upper picture was taken in 1930. The building is now the city's magistrates' court.

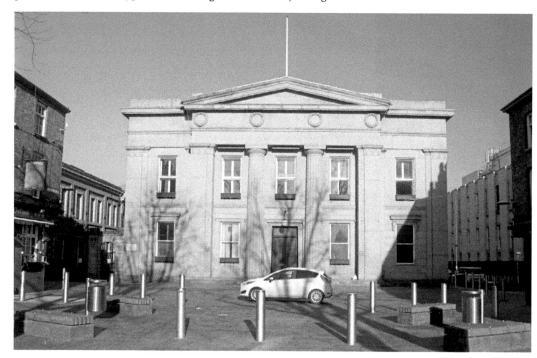

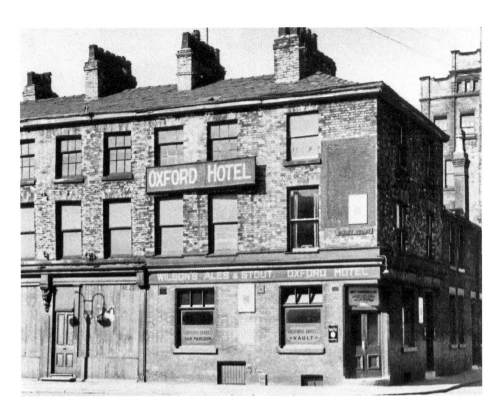

Oxford Hotel
The upper picture shows the Oxford Hotel in the 1950s. It is now called the New Oxford, and frequently appears in the *Good Beer Guide*.

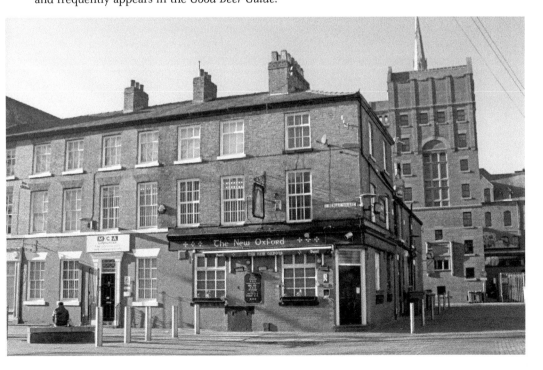

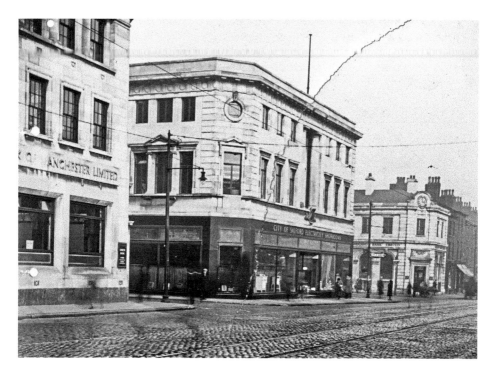

Chapel Street

These photographs show the continuation of Chapel Street; the street was the setting for Henry Hobson's shoe shop in Harold Brighouse's 1915 play *Hobson's Choice*. It was the principal road of the town for many years, seeing the first omnibus service in 1824, horse trams in 1877 and electric trams in 1901.

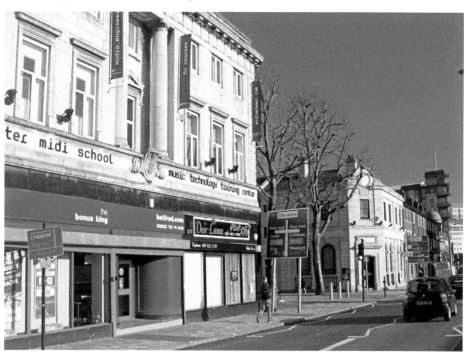

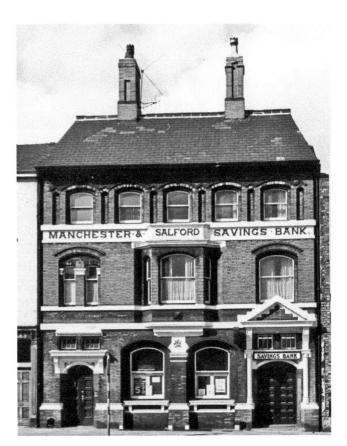

Manchester & Salford Savings Bank
The bank was established in 1818, and this branch was built in 1885.

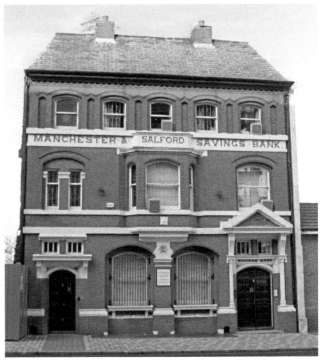

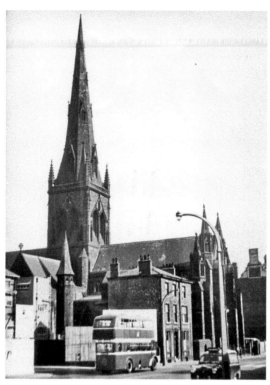

Salford Cathedral

The foundation stone of St John's Cathedral was laid in 1844, and it was consecrated in 1848. It was designed by Matthew Hadfield, and has many medieval-style elements, as well as the tallest spire in Salford. It was the first Roman Catholic church built in a cruciform shape since the Reformation. The upper picture was taken in 1963, and the lower picture shows the *Seed* sculpture by Andrew McKeown, installed in 2002.

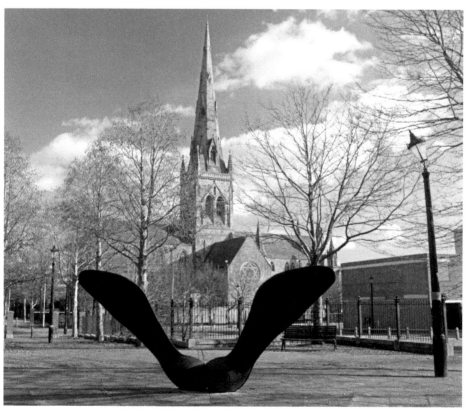

St Philip's Church
This Greek Revival style church was built in 1822–24 to a design by Sir Robert Smirke, and is perhaps the only surviving Neoclassical building in Salford. The portico has an Ionic colonnade and balustraded parapet surmounted by a bell tower with a clock and dome. The lower picture shows the front entrance in 2014, when the colonnade was obscured by scaffolding. The church is at the centre of the Adelphi/Bexley Square conservation area, which extends from the town hall to the River Irwell, and includes ten listed buildings.

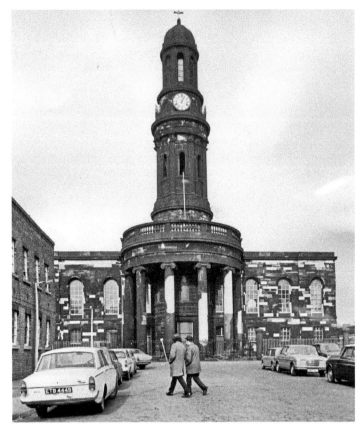

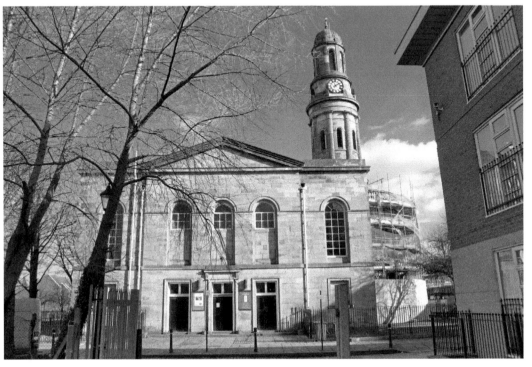

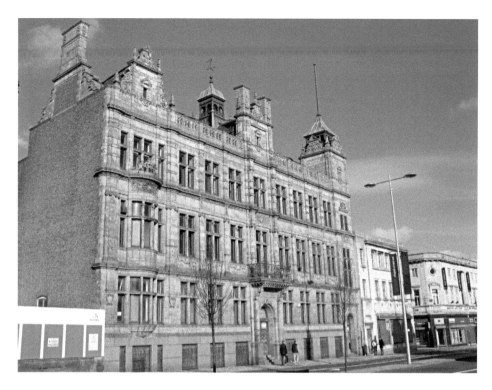

Salford Education Offices and County Court
Two contemporary pictures. The imposing Salford Education Offices are on Chapel Street just before the cathedral. The old County Court, with its entrance arch, is behind St Philip's church. Just around the corner are the Georgian houses of Encombe Place. Even the bollards hereabouts are Grade II listed structures.

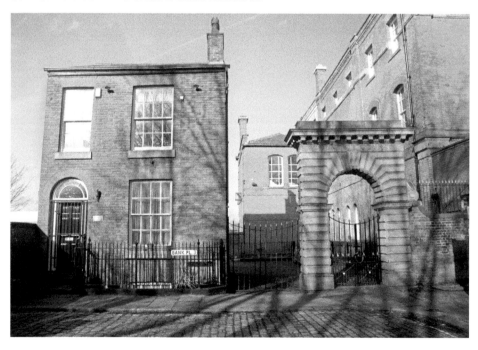

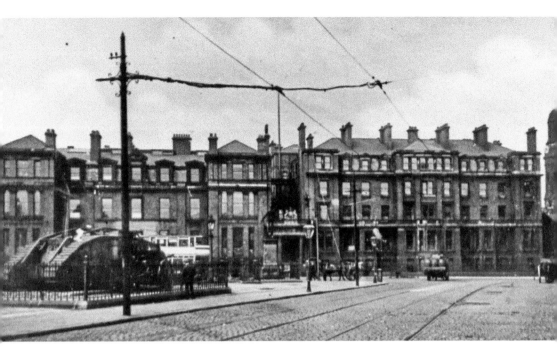

Salford Royal Hospital

The Salford & Pendleton Dispensary opened here in 1827. It admitted its first inpatients in 1847 and added the word 'Royal' to its title in 1847. By the 1870s it was known as Salford Royal Hospital; the present building dates from 1896. It closed in 1993, was converted into apartments in 2002, and its name was transferred to Hope Hospital on Eccles Old Road.

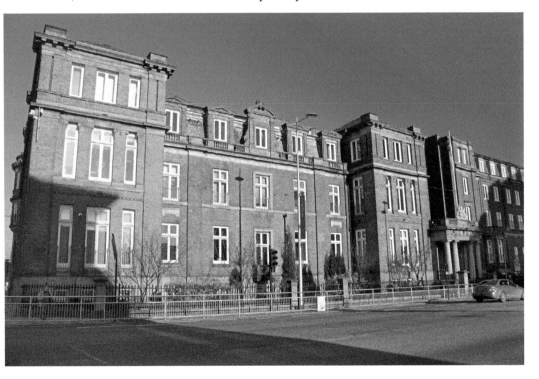

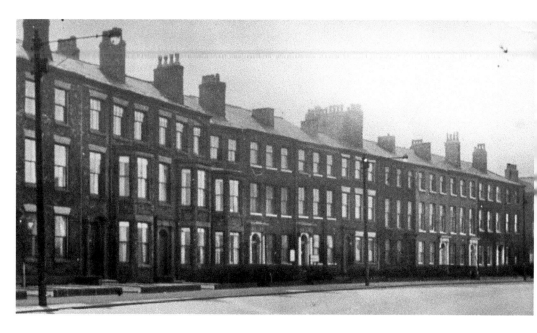

The Crescent

The Crescent overlooks a meander of the River Irwell, and is famous for its row of Georgian terraced houses. Green's map of 1793 shows a few houses already built, and it was completely built up by time the Ordnance Survey mapped the area in the 1840s.

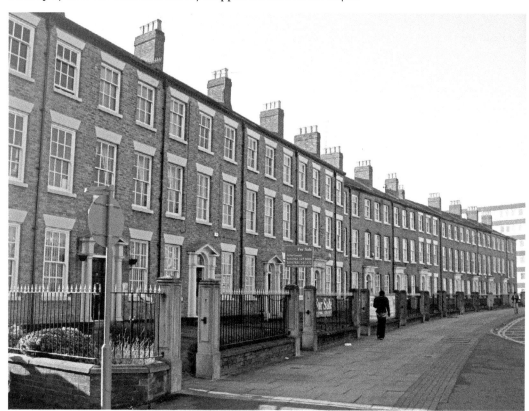

The Crescent

The reverse view looks back to the hospital and the cathedral. The second block of buildings contains The Crescent public house, another pub often included in the *Good Beer Guide*, used by locals and students alike. It was originally called The Red Dragon, and was reputedly frequented by Friedrich Engels and Karl Marx.

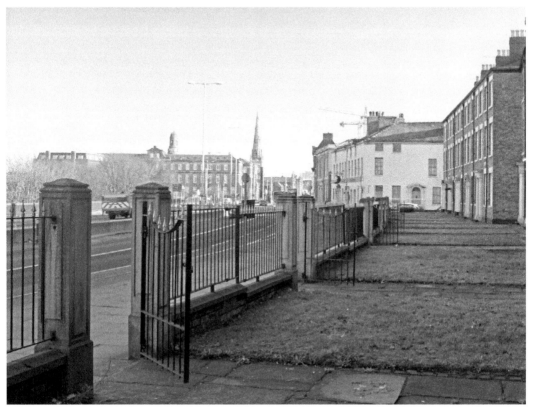

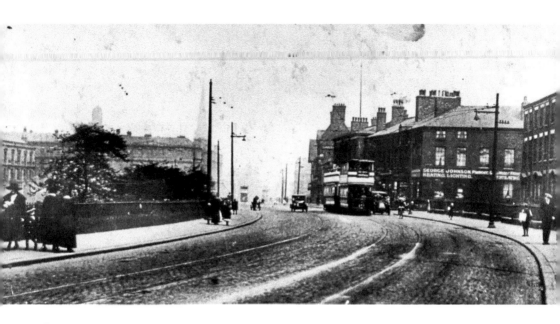

The Crescent

The road in front of the houses is the A6, and was widened into a dual carriageway in the late 1960s. More recently, it has had traffic calming measures applied, including single-file traffic (plus a bus lane) and a 20 mph speed limit; good for pedestrians, but not so good for motorists.

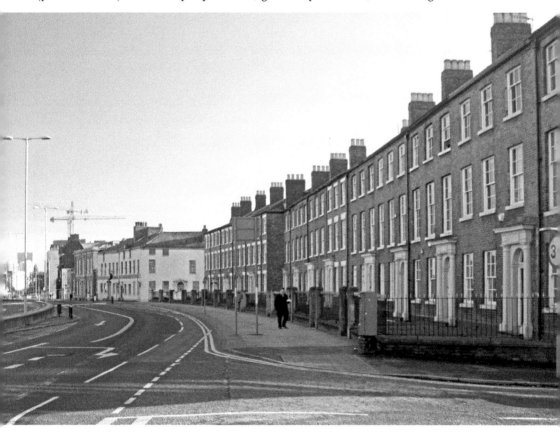

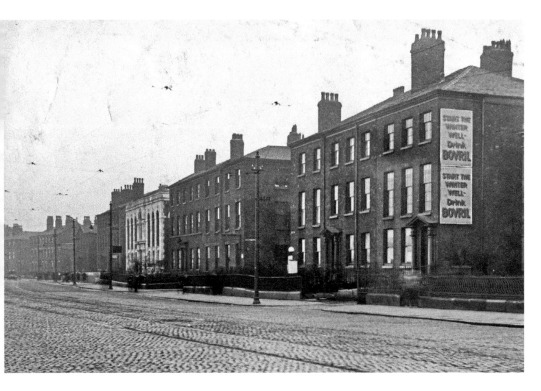

The Crescent

In the lower picture, the first three buildings (from the right) are the boarded-up former police station, Faraday House of Salford University, and the Masonic Hall (which is also visible on the upper picture).

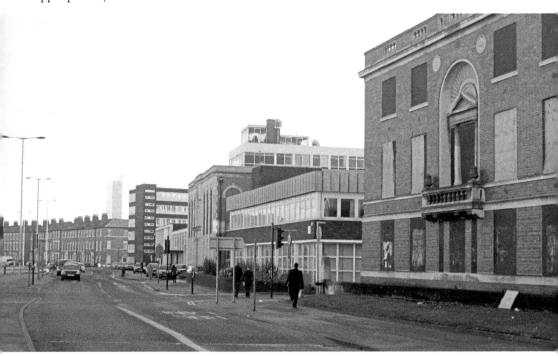

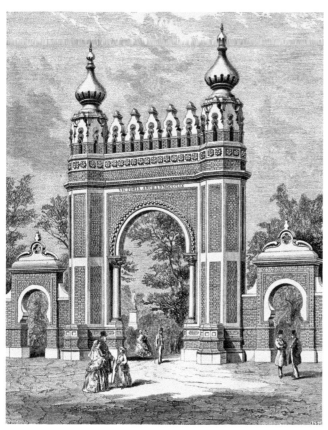

Victoria Arch
The arch was erected in 1851 for the visit of Queen Victoria, and it formed the entrance to Peel Park and the museum and art gallery, surviving until 1937. The site is now one of the main entrances to the University of Salford. The university received its charter in 1967, with the Duke of Edinburgh as its first chancellor.

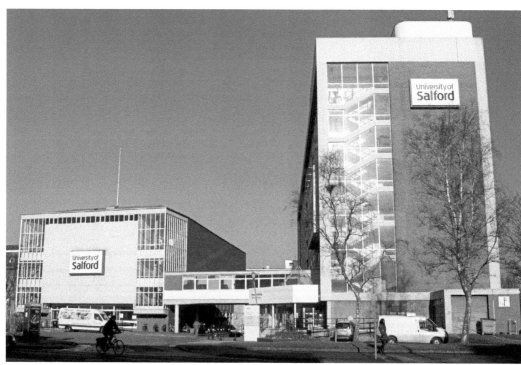

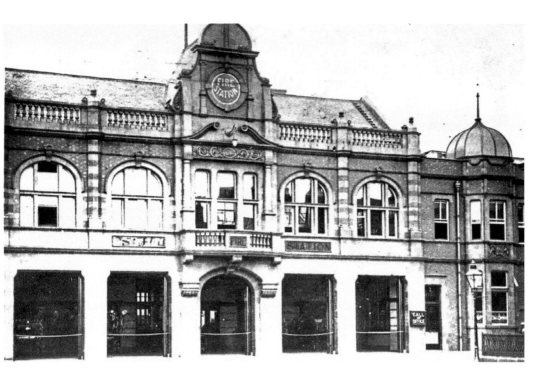

Salford Fire Station

The fire station was built in 1903, including firemen's houses behind. The station closed and the houses were modernised in the 1980s. The station became an art gallery and is now occupied by Salford University. Nearby is a Grade II-listed red telephone kiosk.

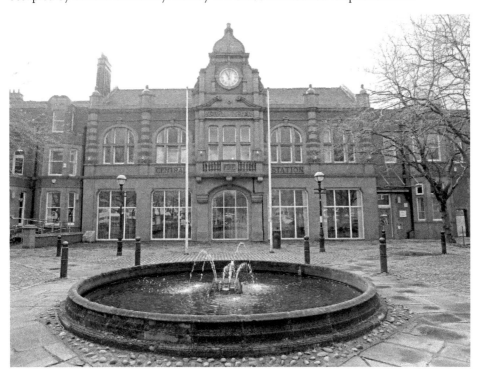

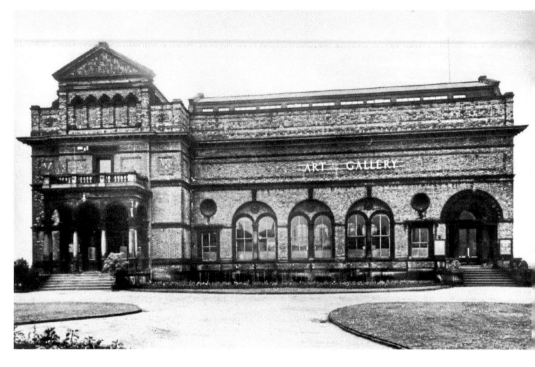

Art Gallery & Museum
The museum was built in 1850, and opened the country's first free public lending library in 1851. Two wings were added by 1857, and more was added in 1936–38.

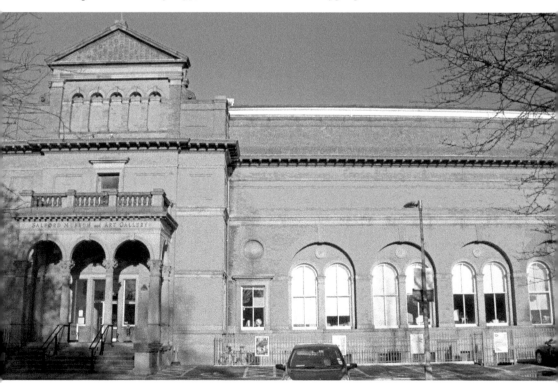

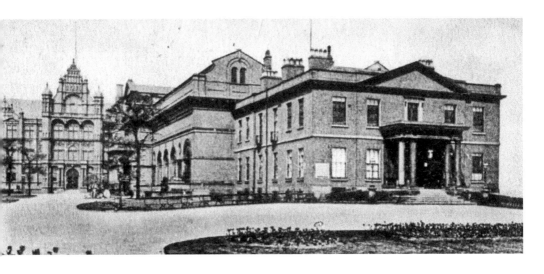

Art Gallery & Museum

This building now contains an art gallery, café, and the Salford Local History Library, whose collection of over 65,000 photographs was used to find the historic photographs for this volume. There is also a fascinating Victorian street called Lark Hill Place (*inset*), named after the house that formerly stood on this site.

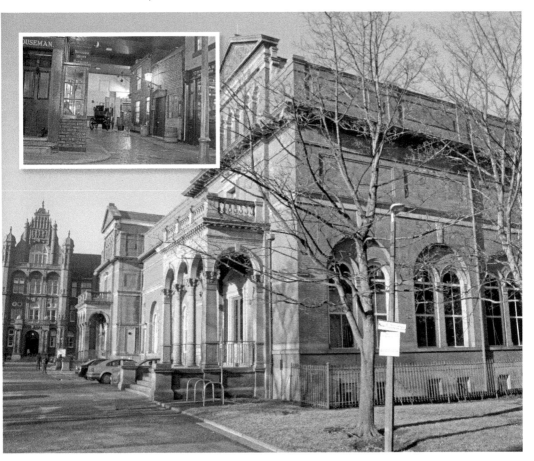

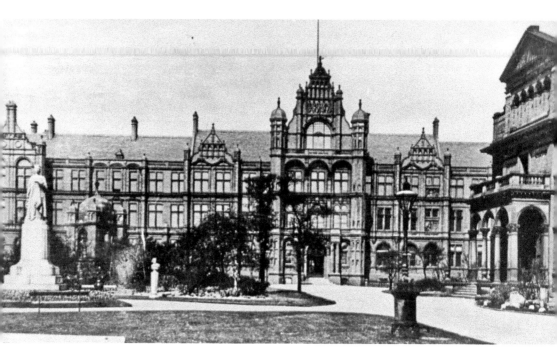

Peel Building

The Peel Building was built in 1896 to house the Salford Royal Technical Institute, and is noted for its terracotta panels depicting craftsmen and engineers at work. L. S. Lowry studied here in the 1920s, and produced a number of sketches and paintings of the buildings and the park. The building was extensively refurbished in 1985 and it now houses the university's School of Environment & Life Sciences. The present author worked in this building as a senior lecturer in geography for most of the 1980s and 1990s.

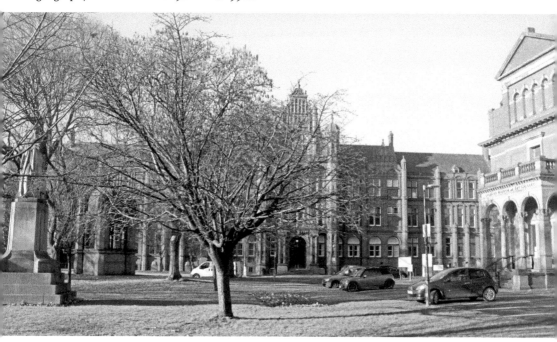

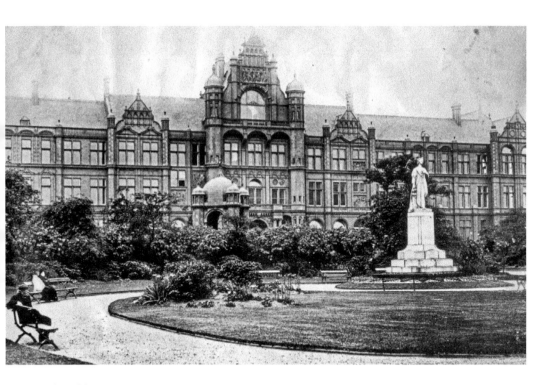

Peel Building

The statues of Queen Victoria and Prince Albert were erected by public subscription and unveiled in 1857 and 1864 respectively. The gazebo-like structure closer to the Peel Building was originally part of the building's ventilation system; both the gazebo and the Peel Building are Grade II listed buildings.

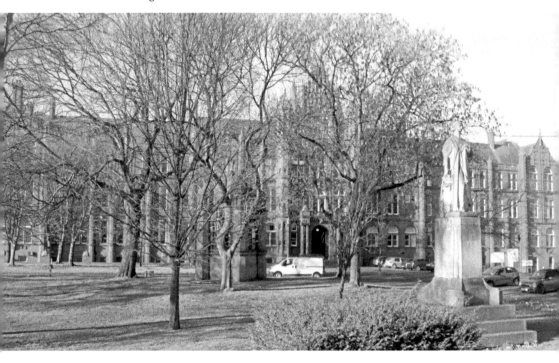

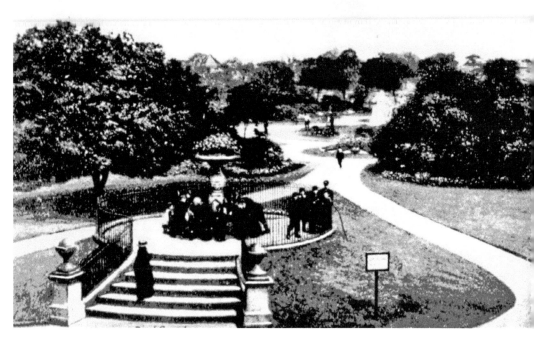

Peel Park

Peel Park was one of the first free public parks in Britain, opened in 1846 and named after Sir Robert Peel. The sundial has gone, as have most of the recreational facilities. The university footbridge over the River Irwell to Lower Broughton is now closed.

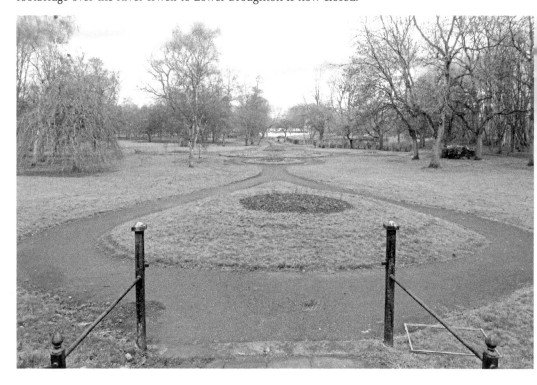

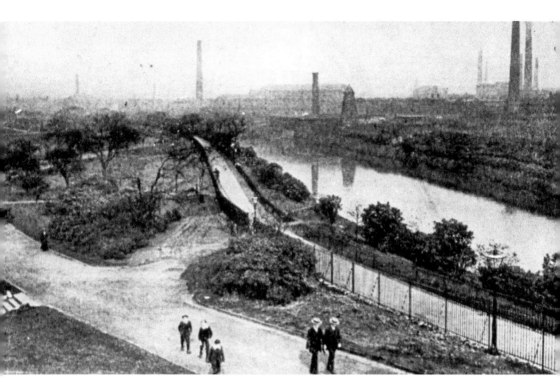

Peel Park
The upper picture was taken in 1913. The massive embankments to stop the River Irwell flooding the park are obvious in both pictures.

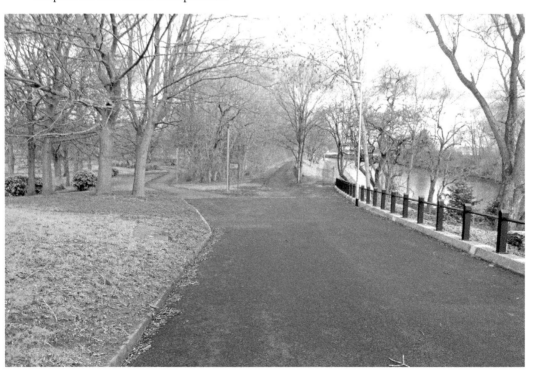

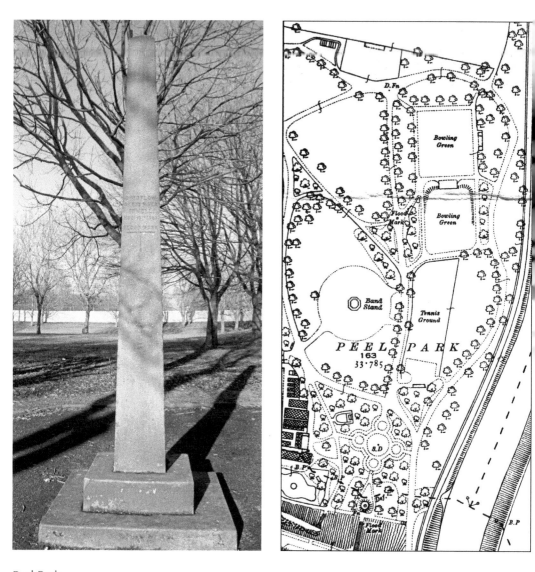

Peel Park

The obelisk records a record flood in the park on 16 November 1866, when the water was 8 feet 6 inches deep. Large parts of Lower Broughton were also flooded and much damage caused; the river is now heavily embanked. The map shows the park as it was in 1915, with glasshouses and various recreational facilities.

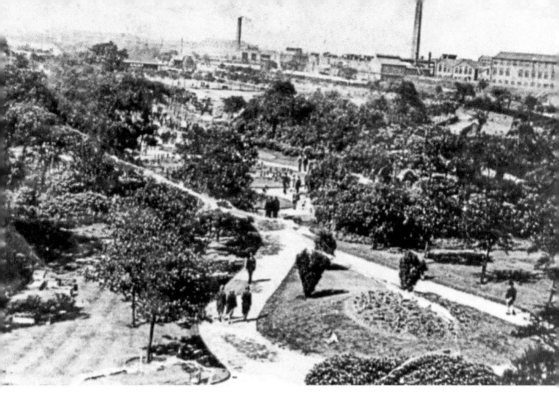

Peel Park

Peel Park's lake, like so many in Salford, was filled in after the Second World War. The picture below was taken in 1908.

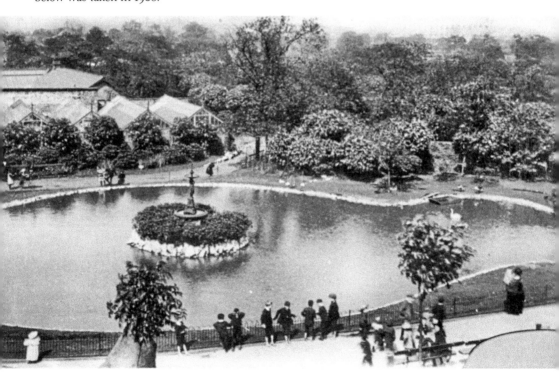

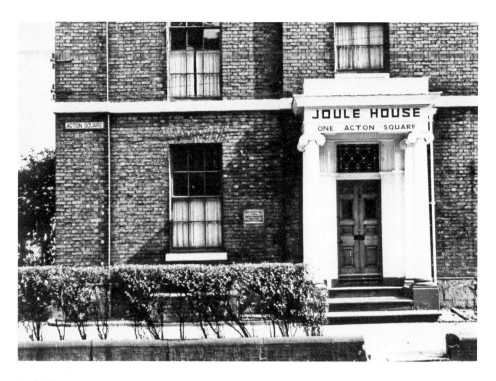

Joule House

A plaque records that, 'James Prescott Joule, scientist, 1818–1889, lived and worked here. A noted scientist who established the principle of the mechanical equivalent of heat. His name has been given to the unit of energy, the Joule.' The upper picture was taken in 1958. The building is now being used by Salford University, appropriately as an energy research centre.

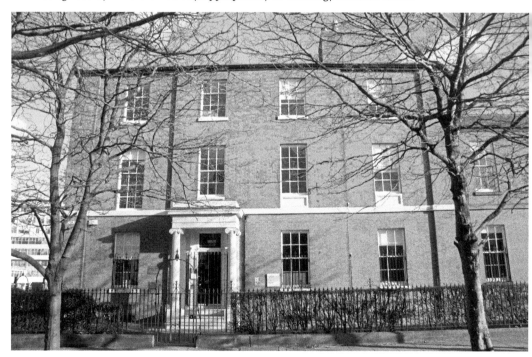

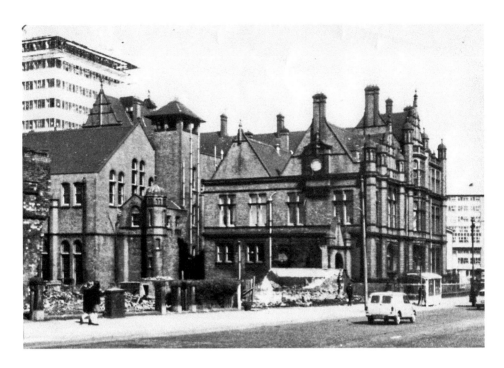

Peel Building

The upper picture shows the tower block behind the Peel Building. It was built in the 1960s between the Peel Building and the art gallery on the condition that the Peel Building was demolished. Happily, it was the tower block that was demolished in 1994. Until the recent traffic-calming measures, the dual carriageway of the A6 was a major barrier running through the university campus.

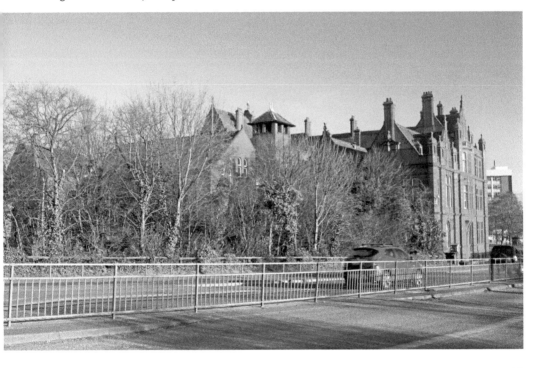

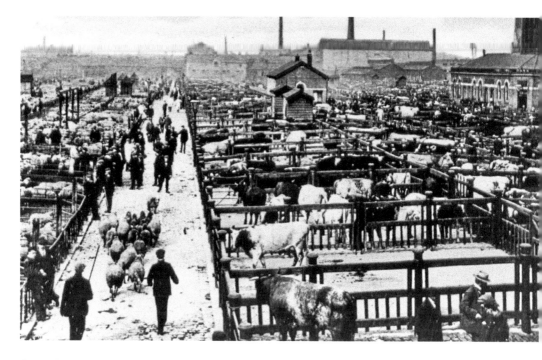

Cross Street

Cross Street once had a large cattle market, originally opened in 1837 and closed in 1931. It was on the left-hand side of the road below. Cattle were brought in by rail to Windsor Bridge cattle station on Albion Street, a block to the east, as well as to Cross Lane cattle station further south. At various times, Cross Street had two theatres (the Regent and the Hippodrome), a hotel, a police station, a drill hall/barracks, and (of course) numerous public houses. Virtually nothing survives of the old Cross Street.

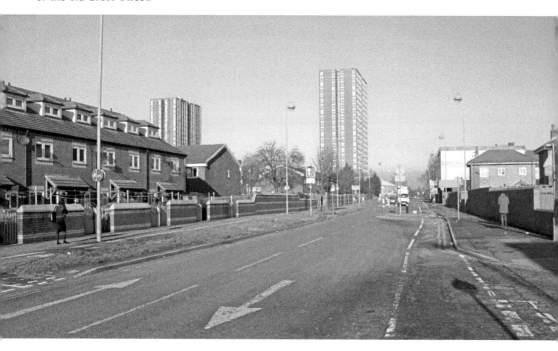

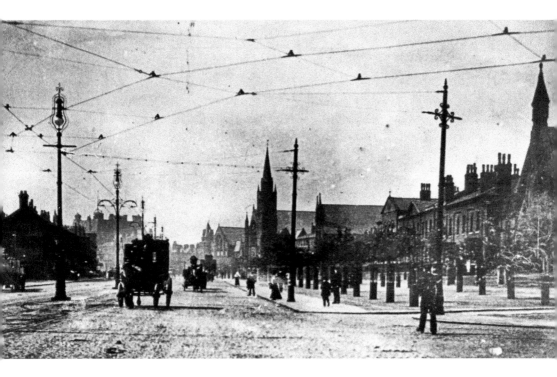

Broad Street

The upper picture was taken in 1914. Originally called New Richmond and Paddington, Broad Street always lived up to its name, but the widening of the A6 in the 1960s virtually trebled its width, and many European-style high-rise flats were built.

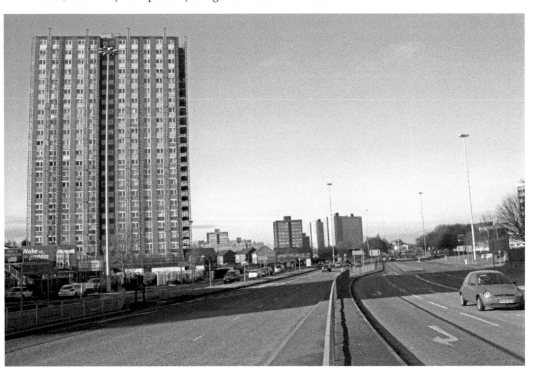

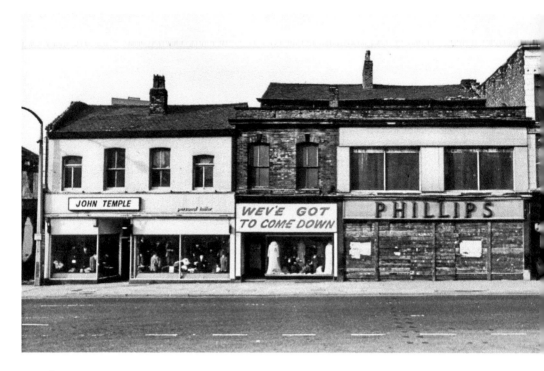

Broad Street

The area on the south-east side of Broad Street had numerous shops, with tightly packed terraced housing behind; most of it was demolished in the late 1960s and early 1970s to make way for the flats. In the upper picture, one shop is already boarded up, while another anticipates demolition. Beyond, the poorly designed Salford Shopping Centre was built and still survives.

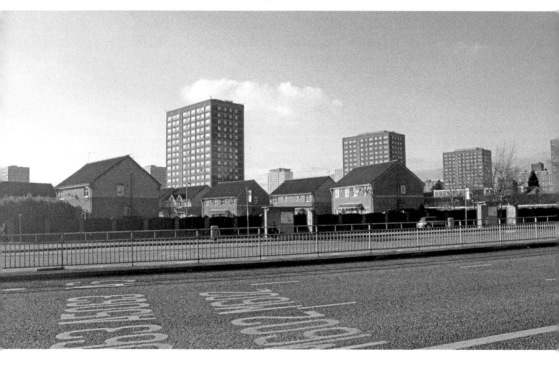

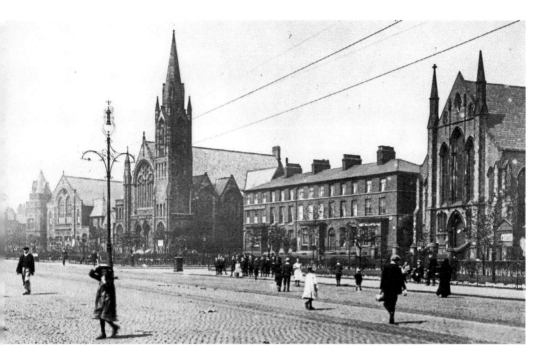

Broad Street

The north-east side of Broad Street once boasted five chapels and churches (three of them Methodist); only the Wesleyan Methodist School building survives, but it is no longer in religious use. One block of terraced housing remains.

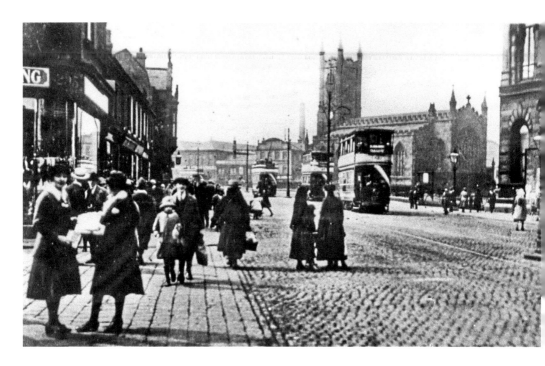

Pendleton

Pendleton was independent of Salford until 1853, having its own town hall (seen on the right of the upper picture). The shops on the left were demolished to make way for an underpass, which was opened in 1968. St Thomas's church was consecrated in 1831 and is almost the sole surviving feature of old Pendleton. The town once had two railway stations – the old station opened in 1843 and the new in 1883 (*see page 92*).

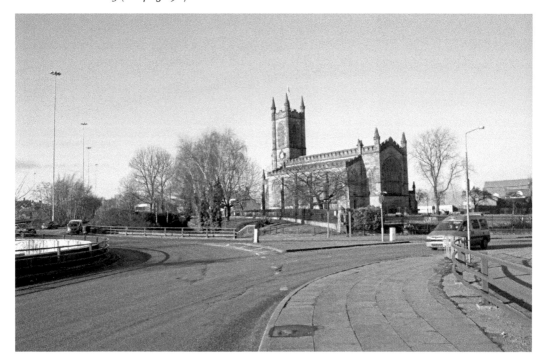

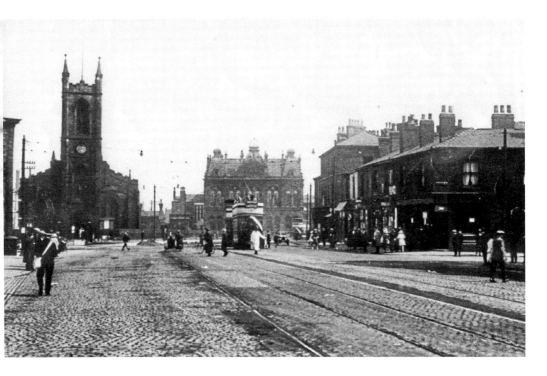

Pendleton

The upper picture was taken in 1930. Looking back towards Salford, St Thomas's church survives, but the town hall and shops have been replaced by roads. In the lower picture, the road on the left is the original Broad Street, while that on the right is merely a slip road from the A6 before it goes into the underpass.

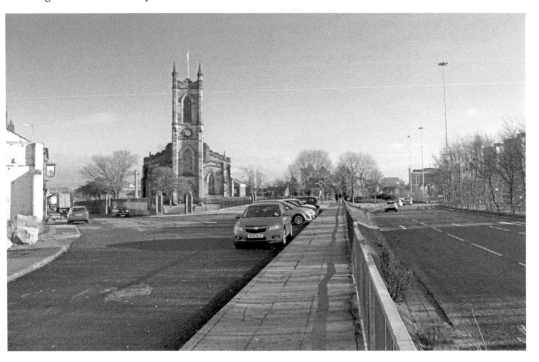

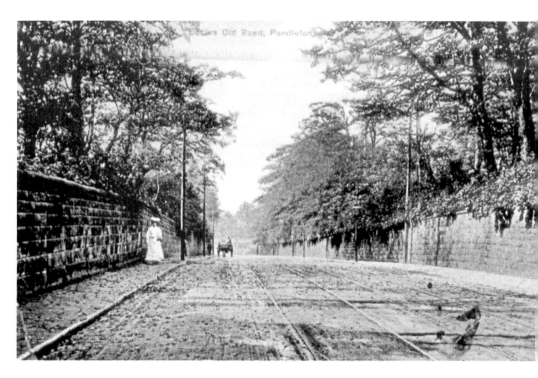

Eccles Old Road

Eccles Old Road was noted for its large houses, protected by high walls and lodges, on higher ground where the wealthier residents of Manchester and Salford could escape from the city. The two pictures are not the same view, but both are close to the highest point of the road.

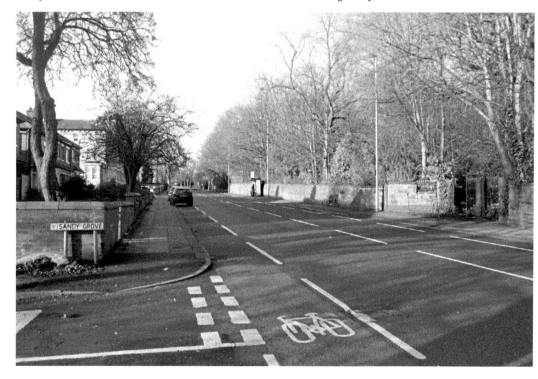

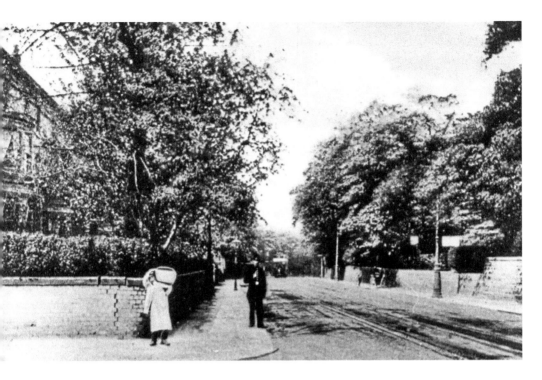

Eccles Old Road

The top view is recognisable by the stone-capped garden wall at the junction with Brentwood. The houses are shown on the 1888 25-inch map; they are now student flats. The first length of Eccles Old Road was originally called Sandy Lane, a name now given to a short side road.

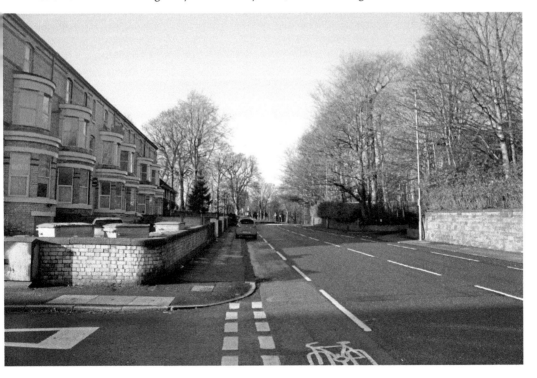

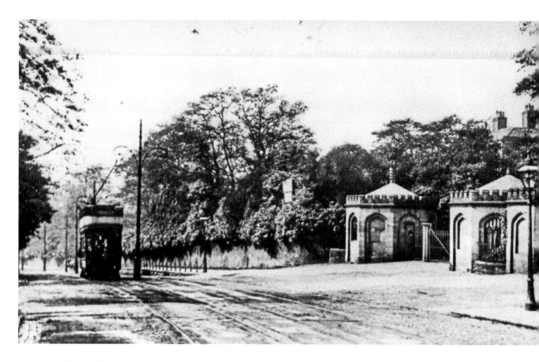

Eccles Old Road

The upper picture was taken in the early 1910s, and show the lodges guarding the entrance to Hope Hall, the home of the Armitage family. This was the largest of the houses along Eccles Old Road, and was set in 5½ acres of grounds. The 1905 25-inch map shows other large houses nearby, including Hart Hill, Hopefield, Fair Hope and Claremont.

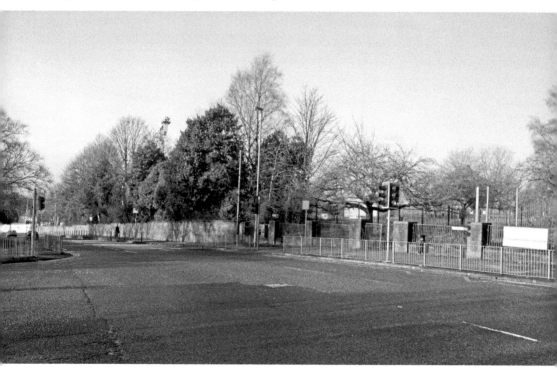

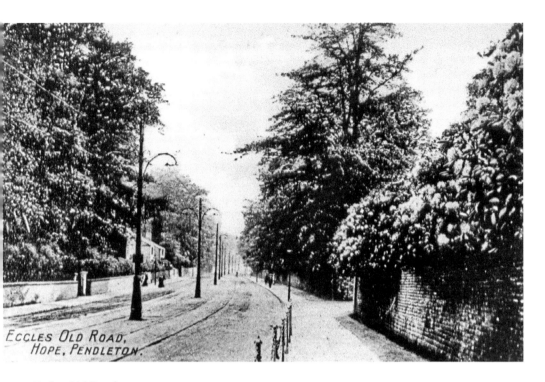

ECCLES OLD ROAD,
HOPE, PENDLETON.

Eccles Old Road

The chain fence alongside the road leading down towards Eccles from Hope Hall still survives, but the ornate tramway poles have long since gone. The road led on to St James's church, Salford Union Infirmary (Hope Hospital) and Eccles.

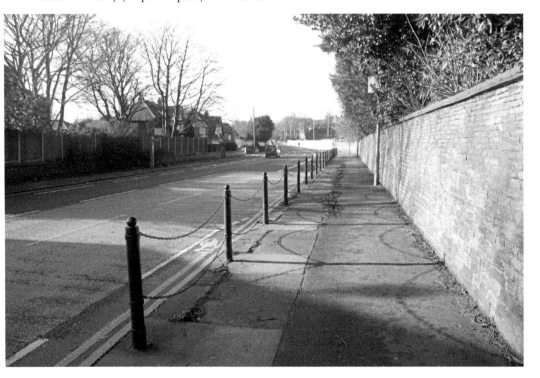

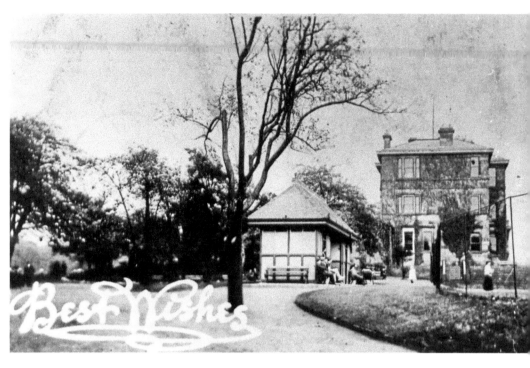

Buile Hill
Buile Hill was built in 1825–27 for Thomas Potter, later Lord Mayor of Manchester. In 1903, it became a Salford park and a museum was created in the house. A mining museum was opened in the 1970s, but it was closed in 2000; the house sadly remains boarded up.

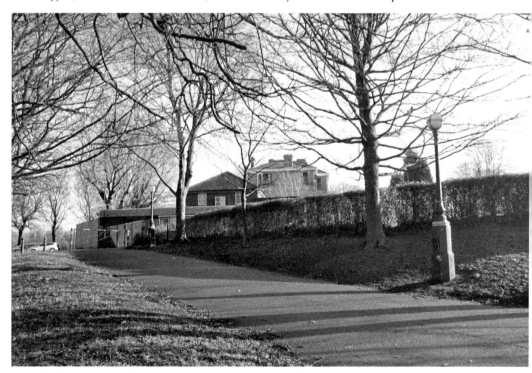

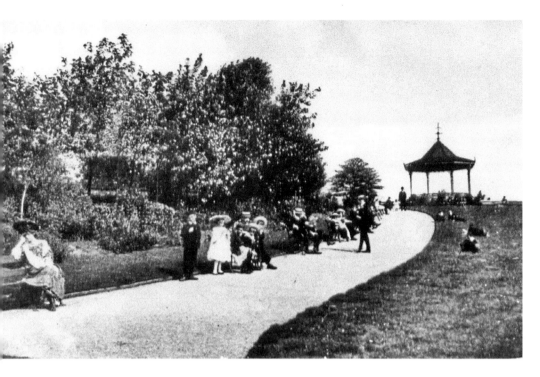

Buile Hill Park

The 1916 Ordnance Survey 25-inch map shows the bandstand to the east of the house; nothing of it remains. The two views are essentially the same. L. S. Lowry is known to have visited the park, and Frances Hodgson Burnett may well have written her children's book, *The Secret Garden*, here.

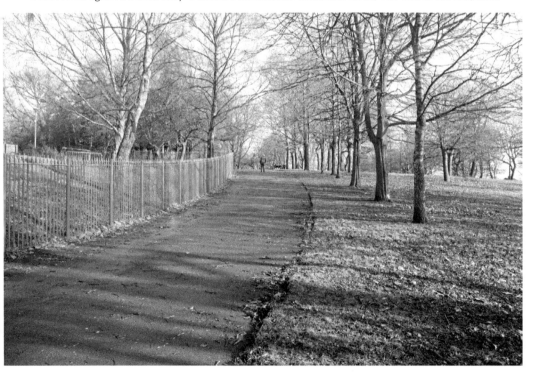

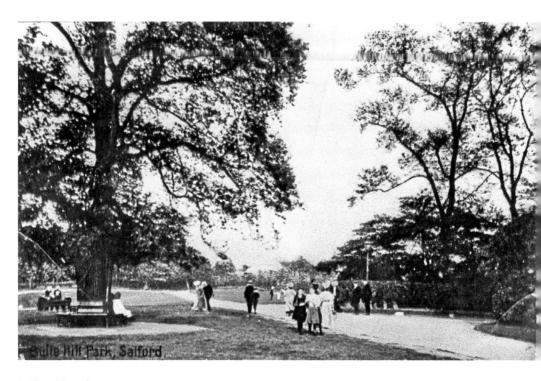

Buile Hill Park

The Hart Hill estate was added to the park in 1938, making it Salford's largest park. The upper picture is a general view in the park, while the two lower pictures are the same view, then and now.

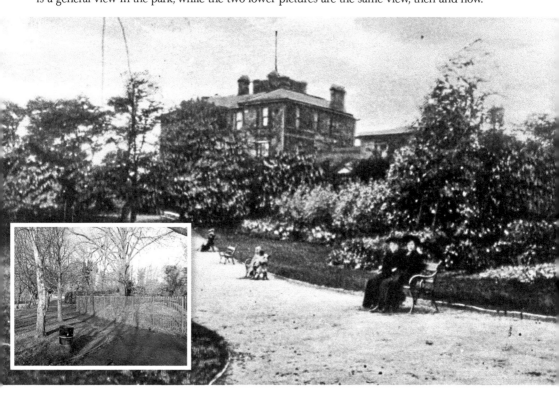

56

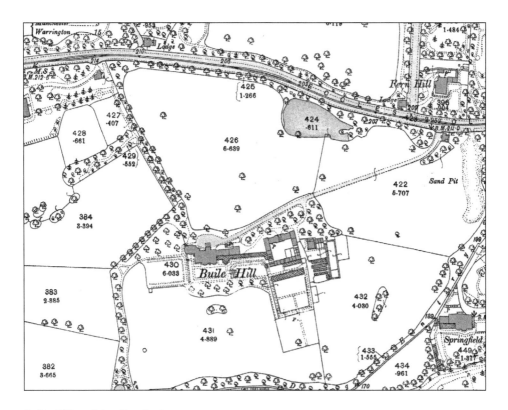

Buile Hill and Seedley Park

Two extracts from the hand-coloured version of the Ordnance Survey 25-inch map of 1889, showing the Buile Hill estate before it became a city park. The two maps overlap – look for plot number 434. In 1889, this area was very much at the edge of built-up Salford. (*Courtesy of Alan Godfrey Maps*)

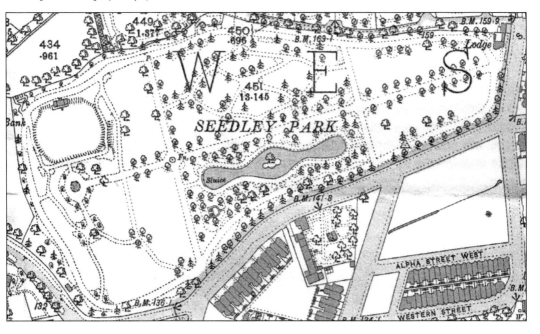

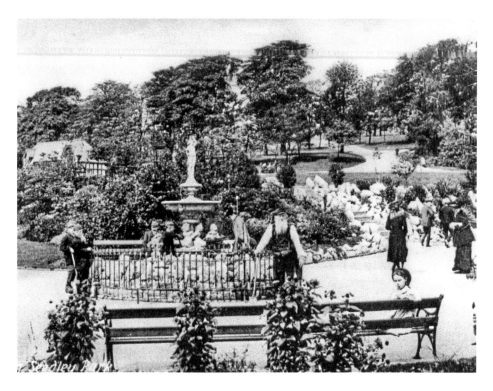

Seedley Park

Seedley Park was opened in 1876. The location of the ornate fountain can be seen as *Fn.* on the lower map on page 57, just west of the lake. The picture was taken in the first decade of the twentieth century; nothing remains of the fountain or the lake.

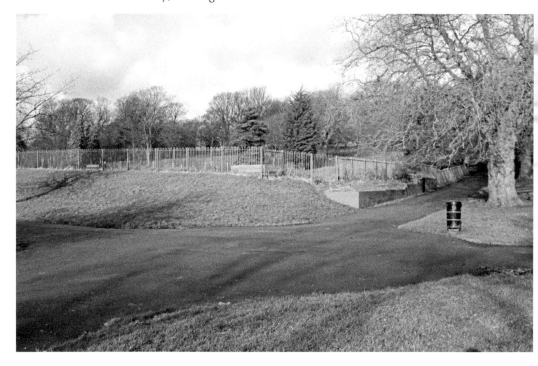

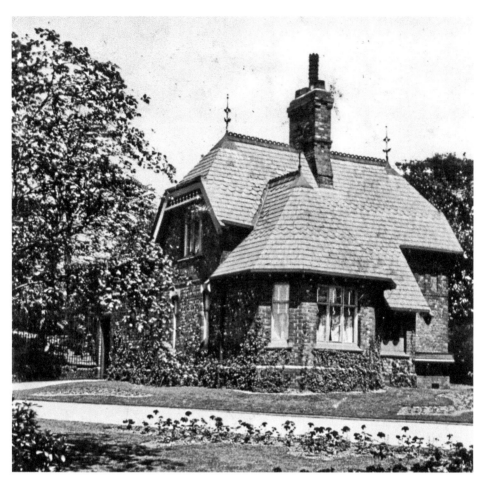

Seedley Park
The ornate lodge at the eastern edge of the park has completely disappeared.

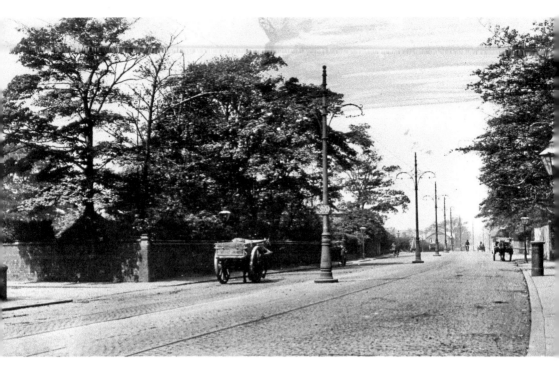

Bolton Road

The upper picture was taken in 1910, but it is impossible to replicate it today; it was probably midway between Pendleton and Irlams o' th' Height. The lower picture shows the original Bolton Road on the left, and the six-lane dual carriageway of the A6 on the right, just before it becomes the start of the A580 East Lancashire Road.

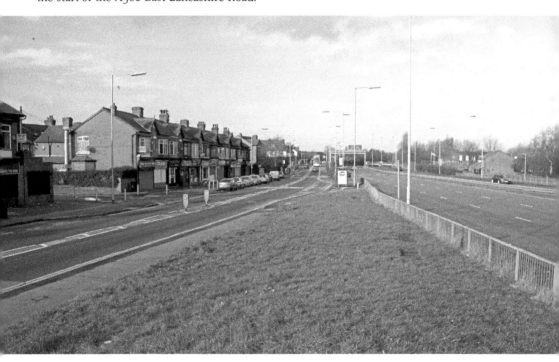

Victoria Theatre

The second route begins in Lower Broughton. The theatre's foundation stone was laid by Sir Henry Irving in 1899. It opened in 1900 and functioned as both a theatre and cinema until 1973, when bingo took over until 2008. It is one of the few surviving older buildings in Lower Broughton – very much a hidden gem. It has an imposing terracotta façade and much of the interior is apparently still intact. A campaign to reopen it began in 2012.

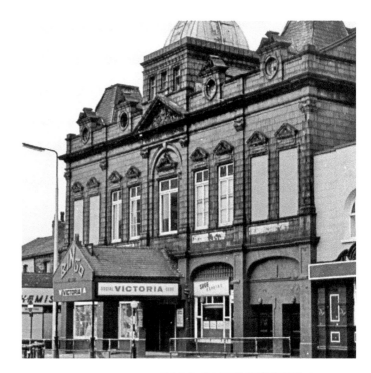

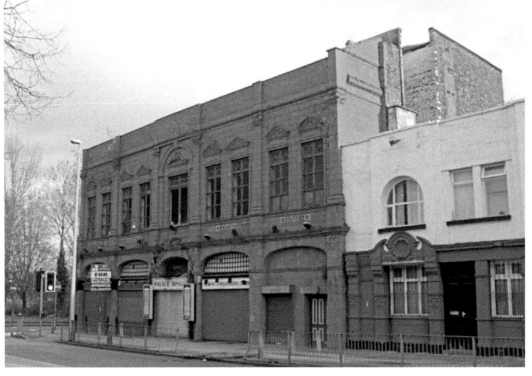

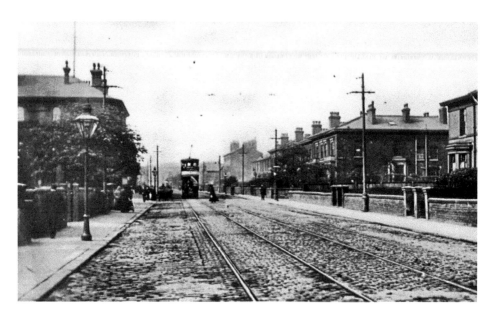

Great Clowes Street

The first length of this street was originally called Broughton New Road, but the road was eventually named after the Clowes family, who owned most of Broughton. Broughton-cum-Kersal became part of Salford in the 1850s. These views look up the street from the south.

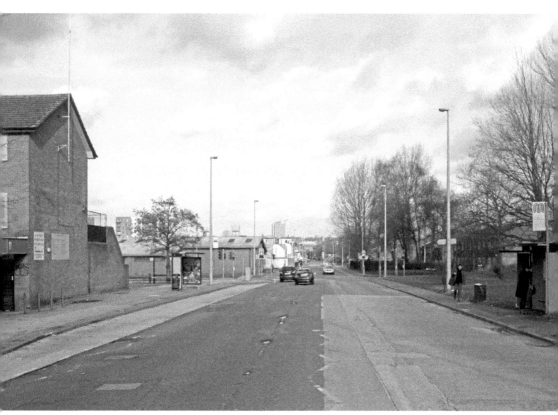

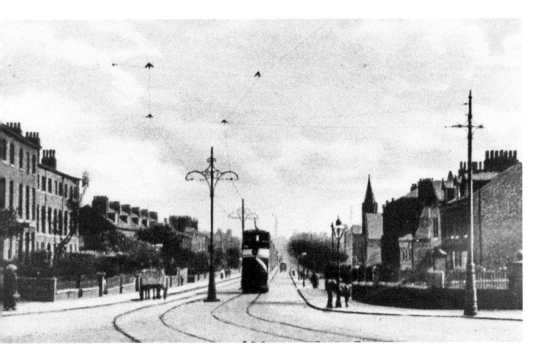

Great Clowes Street

These views look back down Great Clowes Street towards Salford from the junction with Camp Street. The 1931 25-inch map shows a Methodist church, public baths, a Union church, a club, a bowling green, a laundry and a picture theatre, all on the right-hand side between here and Broughton Lane.

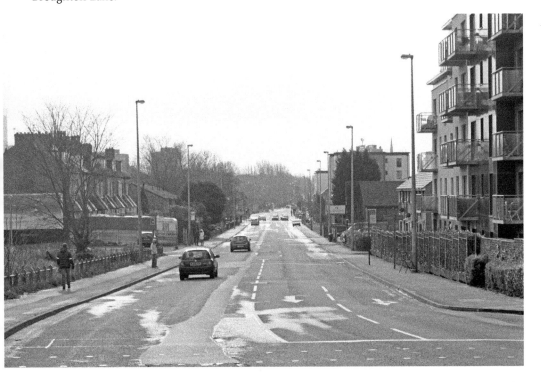

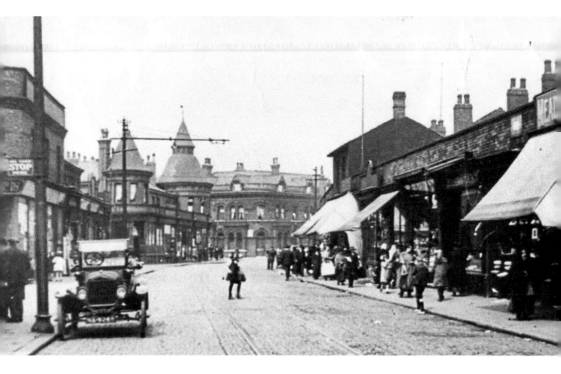

Lower Broughton Road

The start of Lower Broughton Road formerly had many shops and public houses, notably the Bee Hive and Poet's Corner, seen at the centre of the picture at the junction with Hough Lane. The upper picture was taken in 1921, but the area has now totally changed.

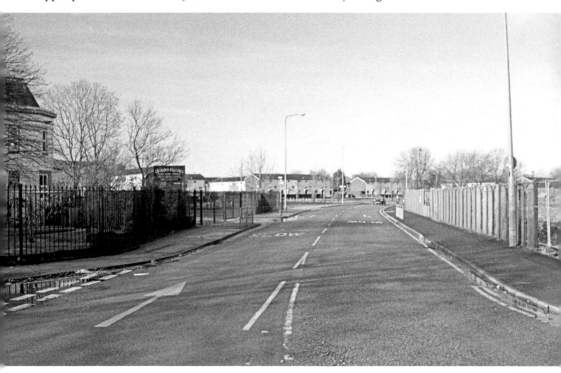

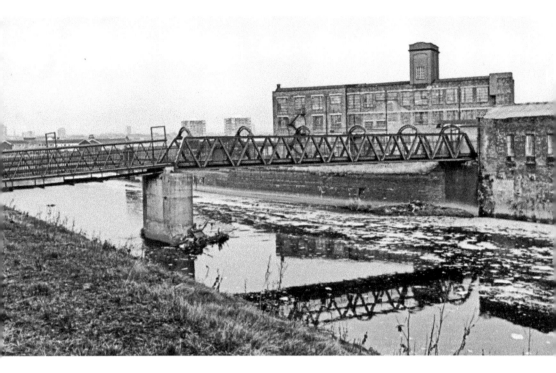

Adelphi Footbridge

A short walk along Riverside leads to this footbridge, opened in 1902, which connects Lower Broughton (on the left) to Adelphi Street and Silk Street. A colourful plaque records the bridge's opening.

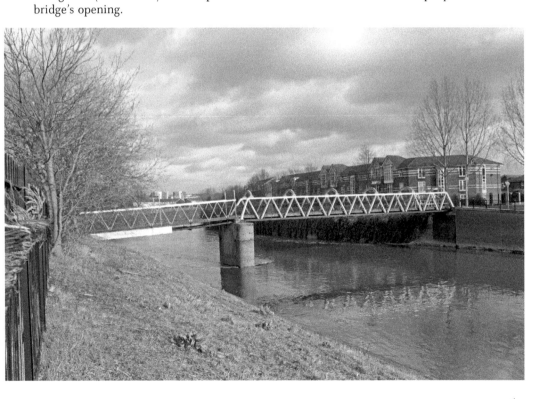

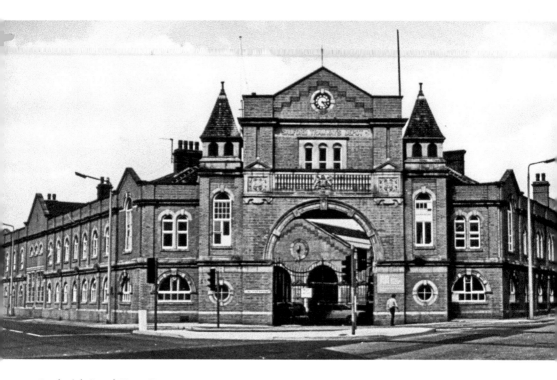

Frederick Road Tram Depot

This depot opened in 1901 to house the new electric tram fleet; the arch and offices were added in 1907. Salford once had 230 trams, and there was another depot at Weaste, but the trams ceased operation in 1947. The internal shed and workshops have been demolished, and a new, taller frontage now provides student accommodation.

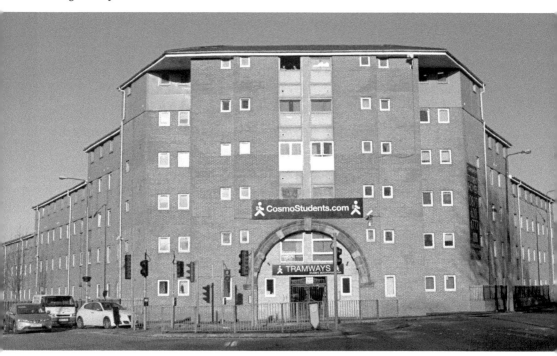

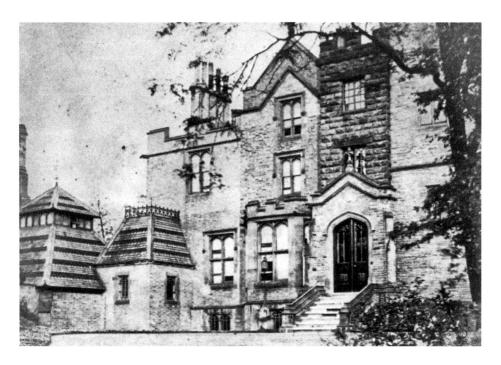

Castle Irwell

The imposing Castle Irwell mansion, home of the Fitzgerald family, stood at the narrowest point of the River Irwell's meander. It was shown still standing on the Ordnance Survey 25-inch map of 1889. Its name continued to be used when Salford University bought the site for student housing in 1972. The main pavilion became a social venue for Salford University students, known as 'The Pav'; it closed in 2009.

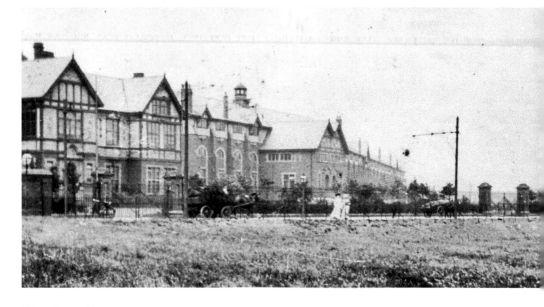

'Manchester' Racecourse

Manchester's first racecourse was on Kersal Moor (*see page 79*). The racecourse operated here from 1847 to 1867. It then moved to Weaste, but due to the expansion of Salford Docks it returned here from 1902 to 1963. The most famous race was the November Handicap; the last winner was ridden by Lester Piggott. The race was moved to Doncaster when the course closed.

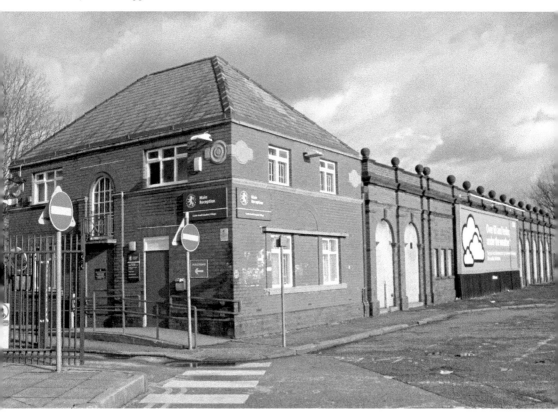

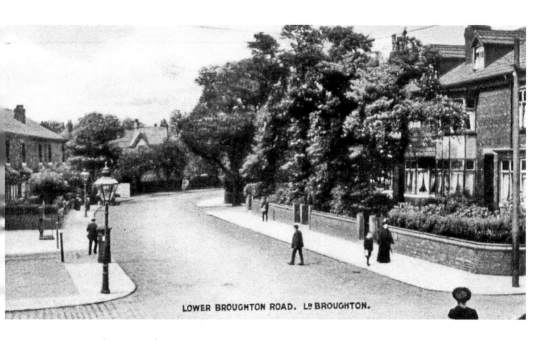

LOWER BROUGHTON ROAD. L^r BROUGHTON.

Lower Broughton Road

Two views of the continuation of Lower Broughton Road from its junction with Cromwell Road and Great Cheetham Street. It leads to The Cliff conservation area, which covers 64 acres and was created in 1976. Beyond this point, the housing was mostly higher-class villas rather than terraces; there are twelve Grade II listed buildings in the area, including a sports pavilion. The only unfortunate blot on the landscape is Manchester United FC's training ground.

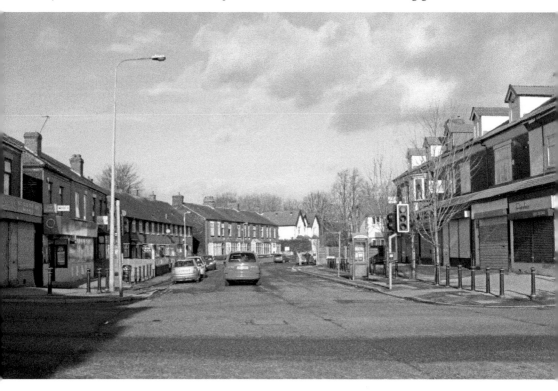

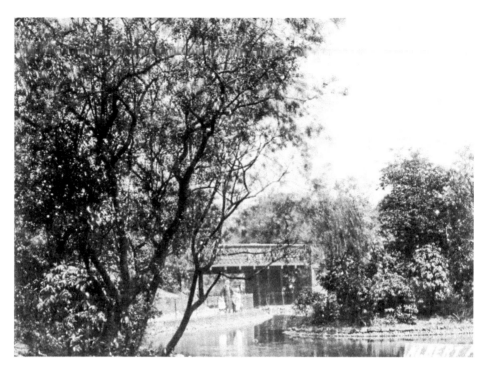

Albert Park

This park was opened in 1877. Covering 16 acres, it had a lake and over 5 miles of walkways. The upper picture shows 'the Swan's Retreat' in 1920; the lake was drained in the late 1940s. The park now has a set of all-weather sports pitches, and is a drab and featureless shadow of its former self.

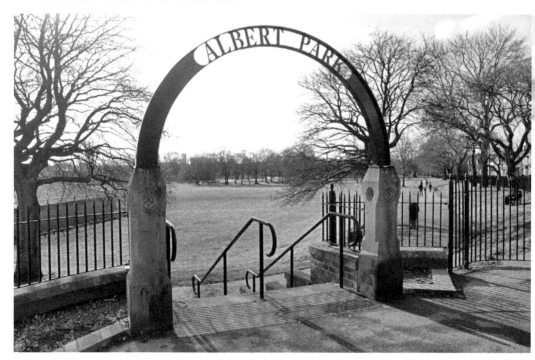

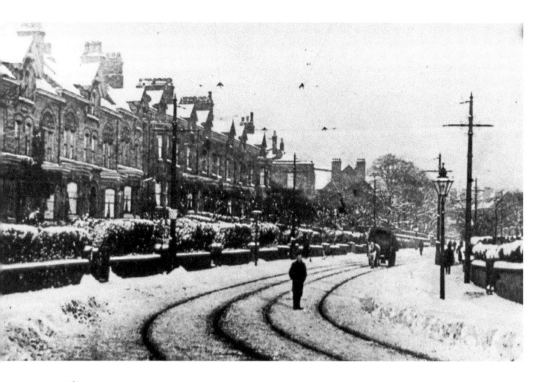

Great Clowes Street

The upper picture shows the street covered in snow around 1907, with the tram tracks cleared to allow services to run. The houses are higher-class dwellings with front gardens, and are in The Cliff conservation area.

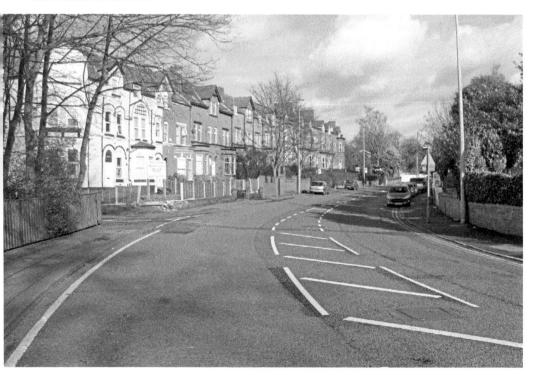

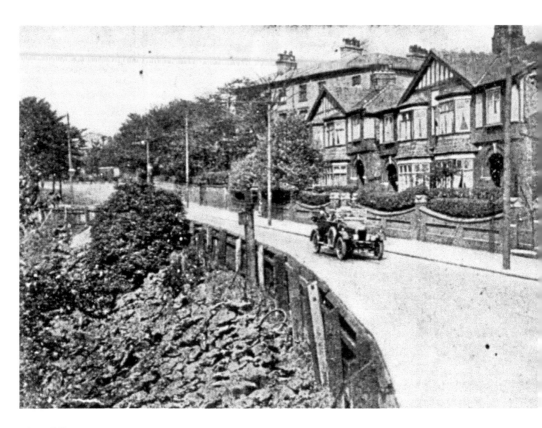

The Cliff

The upper picture shows the top of Great Clowes Street before 1927. The original cobbles and tramlines are still visible in the lower picture.

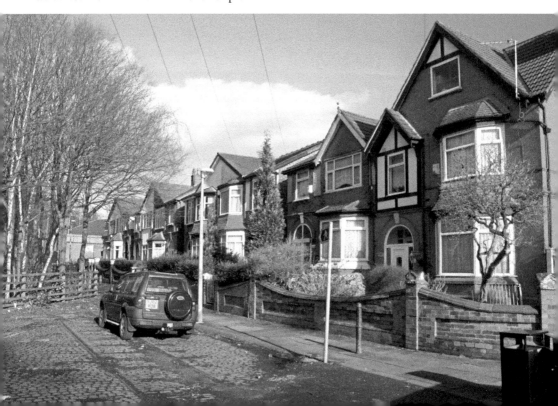

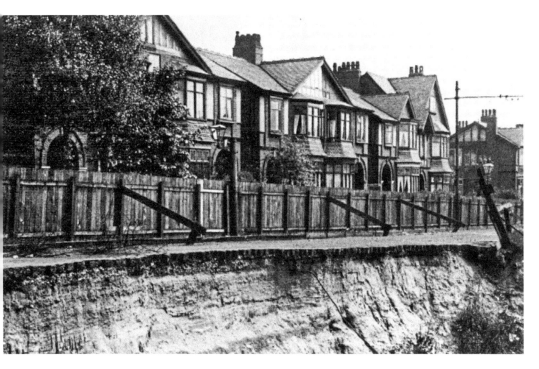

The Cliff

The Cliff is a geologically unstable area, and landslips have occurred for many years, most noticeably after a storm on 22 July 1927, when Great Clowes Street was severed; traffic then had to turn up Knoll Street to reach Bury New Road. The houses now have only a narrow path between them and the cliff.

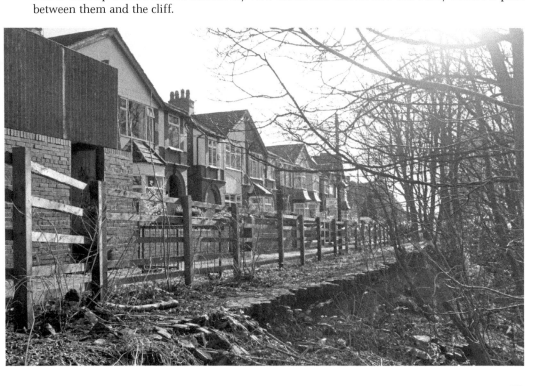

Bury New Road

The remarkably straight alignment of Bury New Road is due to its being on the line of the Roman road from Manchester to Ribchester. Most of it went out of use and only a short length is shown on Yates' map of Lancashire, surveyed *c.* 1780. However, it was made into a turnpike (toll) road in 1826, as an improvement to Bury Old Road further east.

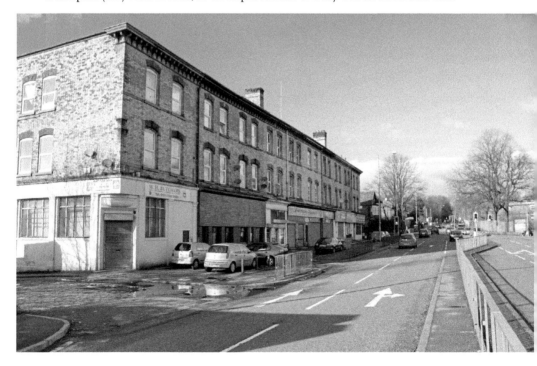

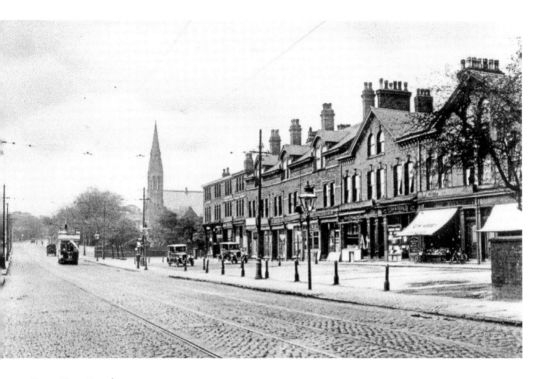

Bury New Road

The pictures here and on the previous page show the two sides of Broughton market place; there were zoological gardens on the right-hand side in the years around 1840. The buildings on the east side have gone, as has the church in the distance (it was described on the 1933 25-inch map as 'New Church').

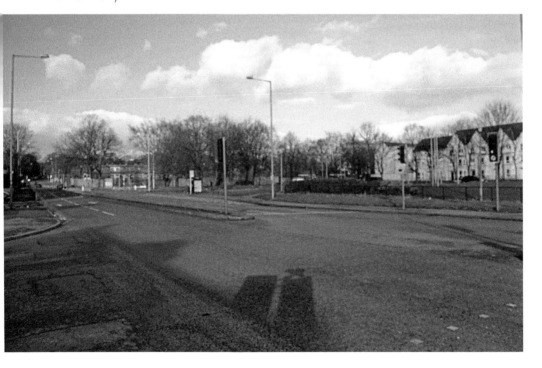

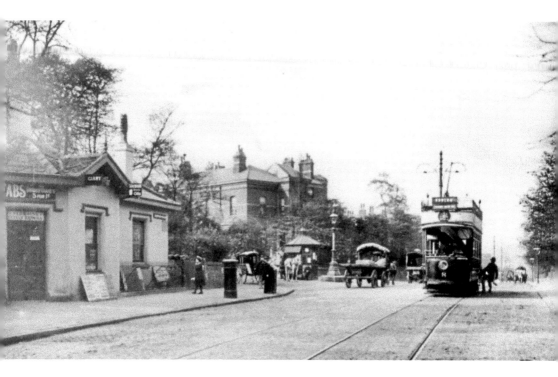

Kersal Bar

Kersal Bar was the name of the turnpike toll house, which still survives. Salford trams terminated here. Higher Broughton (also known as Broughton Park) was similar to the area around Buile Hill as it had many large villas on this high ground above the city.

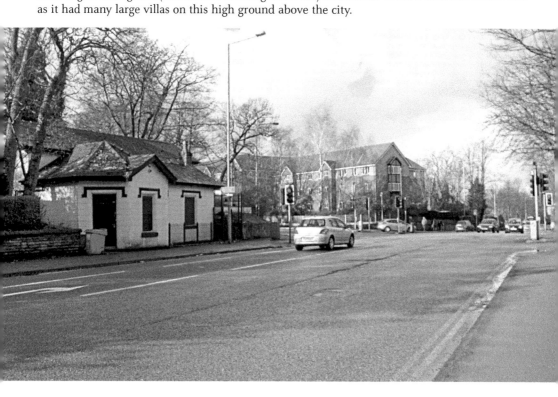

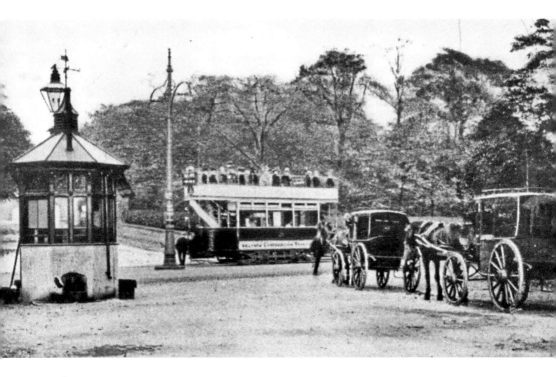

Kersal Bar

The cabmen's shelter is seen from Moor Lane, looking across Bury New Road to Sedgley Bank and Singleton Road. The villas across the main road included Kersal Crag, Birch House, Manor Heath and Summer Hill, and similar houses covered the area across to Bury Old Road, including Broughton Old Hall.

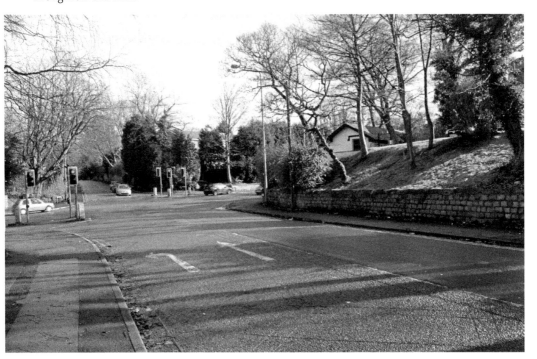

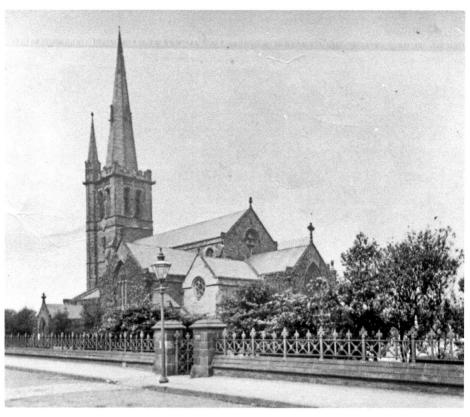

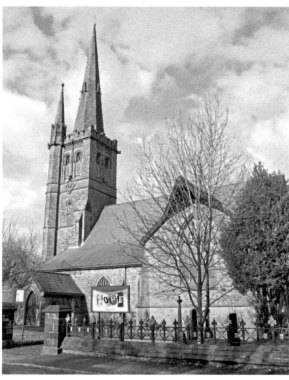

St Paul's Church
The church, seen above in 1903, was built for Col. William Clowes and Miss Atherton of Kersal Cell in 1851/52. It is on the highest point in Salford and has a tall tower and double spire. It suffered a severe arson attack in 1987, but has been rebuilt as a modern church within the surviving walls.

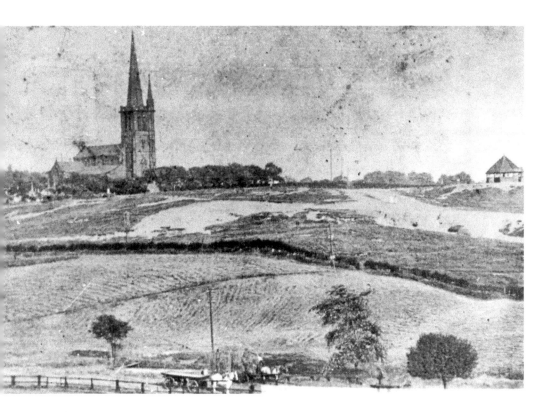

Kersal Moor

Kersal Moor was the location of 'Manchester' racecourse from 1681 to 1847; the races were held in Whit week. In 1838, a Chartist meeting was held on the moor, attracting around 300,000 people. The moor was acquired by Salford in 1936 for preservation as an open space; it is now a local nature reserve, home to several unusual plants, and also has a golf course.

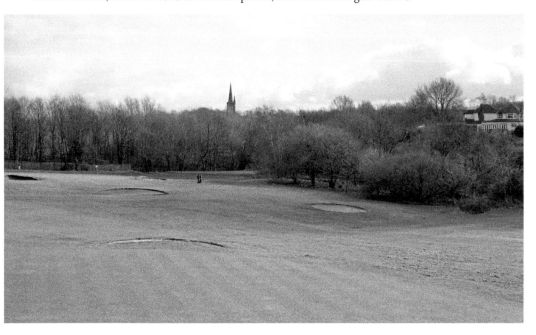

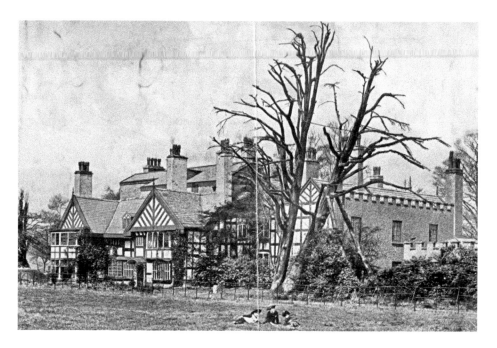

Kersal Cell

This was originally a medieval monastic cell. The present building, the second oldest in Salford, was built in 1563, and was bought by the Byrom family in about 1660. It was the home of John Byrom (1692–1763), a local landowner, poet and hymn writer (including 'Christians, Awake'). The building was threatened with demolition, but was bought by a Salford councillor in 1949, who opened it as a nightclub and restaurant. It is now two private houses.

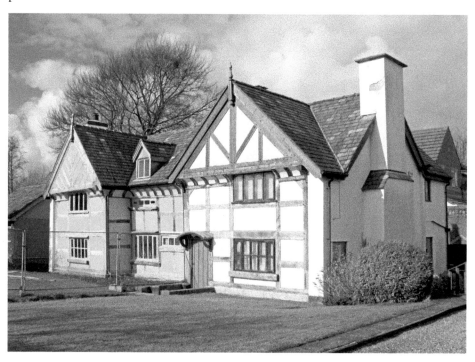

Route Three

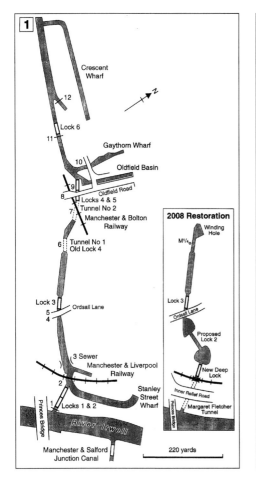

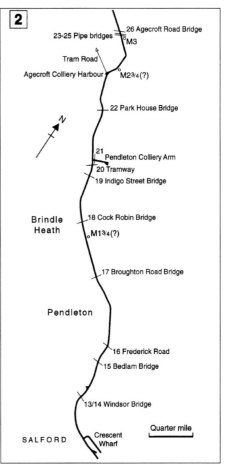

Manchester Bolton & Bury Canal

The Manchester Bolton & Bury Canal (MB&BC) received its Act of Parliament in 1791. It was opened from Bolton and Bury to Salford by 1797, and connected to the River Irwell in 1808; its total length was 15 miles 1 furlong. The canal remained isolated from the rest of the canal system, but was finally connected across the River Irwell to the Bridgewater Canal via Hulme Locks in 1838, and to the Rochdale Canal via the largely underground Manchester & Salford Junction Canal in 1839. The MB&BC was essentially a coal-carrying canal, with numerous collieries nearby. In the 1830s, the canal company proposed to turn itself into a railway company, but eventually decided to keep the canal, and built the Manchester & Bolton Railway, which was opened in 1838. Traffic continued between Salford and Clifton until 1950; the whole canal was officially closed by 1961. The Manchester Bolton & Bury Canal Society was formed in 1987. The construction of the Inner Relief Road in Salford in 2001/02 threatened to sever the canal close to its connection with the River Irwell, but a tunnel was created to preserve the route. The restoration of the canal was announced in 2002, and funding was obtained for the first stage in Salford, with the canal as the focal line of a major redevelopment scheme. Construction work began on this Middlewood site in 2007, and the first length was reopened in 2008. The next stage of restoration is likely to continue behind The Crescent.

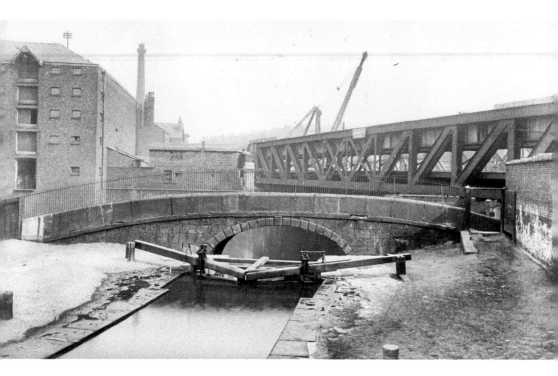

Lock 1

The upper picture, taken in 1901, shows a full Lock 1 with Bloody Bridge and Princes Bridge beyond. The lower picture is essentially the same view, but taken after the 2008 Middlewood restoration, accessible from the Inner Relief Road. Staircase Locks 1 and 2 have been converted into a tunnel under the road, leading to a new deep lock, the third deepest in the country.

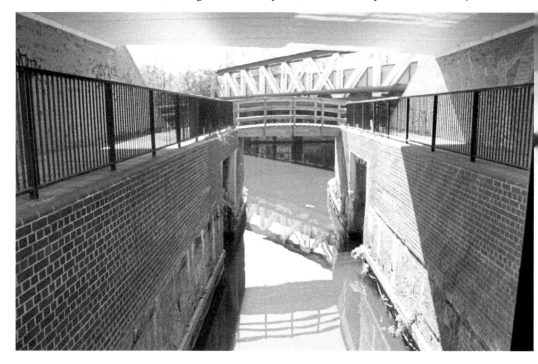

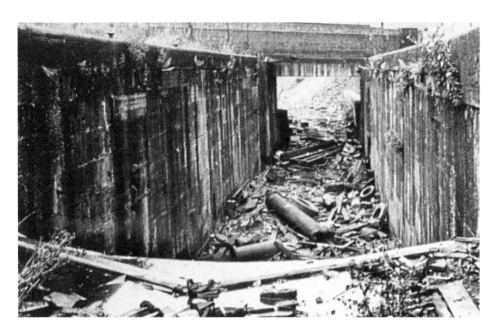

Lock 3

Many of the old pictures were taken in 1954, and show the canal in a largely derelict state. Lock 3 is close to East Ordsall Lane Bridge, which was rebuilt as part of the 2008 restoration. Water is back-pumped from the River Irwell to provide the water supply.

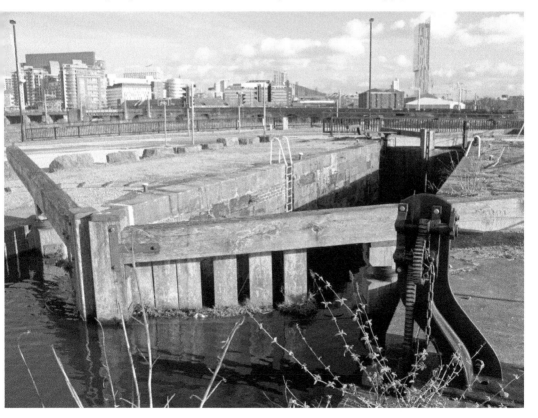

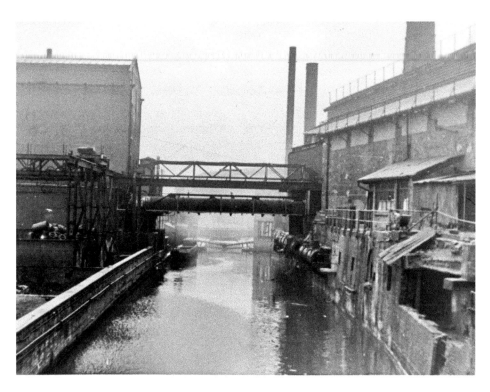

Lock 3

Two views looking back along the canal to Lock 3. The canal once ran through an engineering works, but the length restored in 2008 leads the eye towards the Beetham Tower.

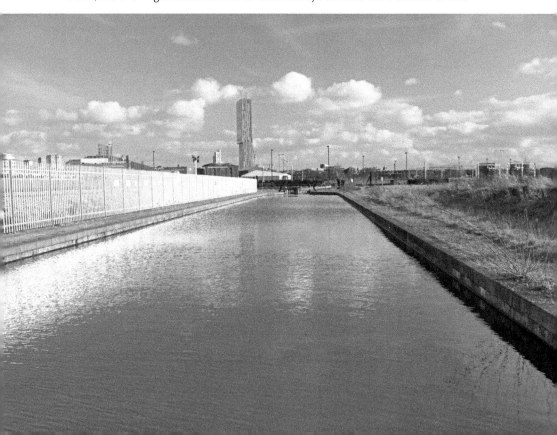

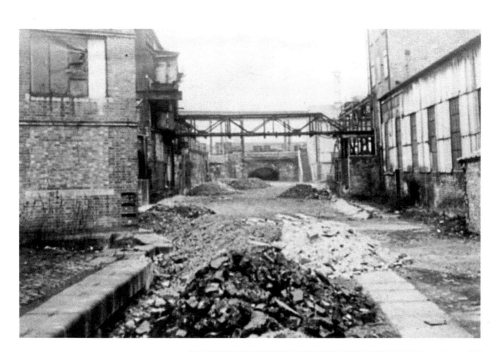

Lock 3 and Salford Tunnel No. 1

Two views looking towards the first tunnel; the above picture shows Lock 3 in the foreground. The picture to the right is halfway towards the tunnel, with the engineering works surrounding the canal.

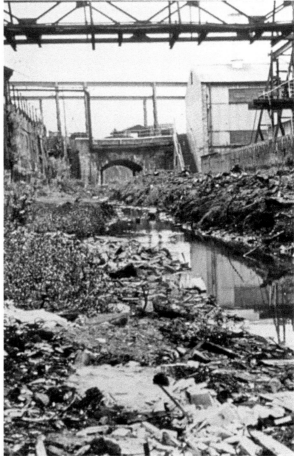

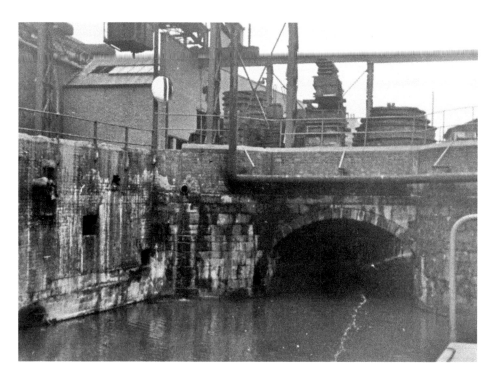

Salford Tunnel No. 1

Again it is difficult to believe that these are essentially the same view. Originally the tunnel was Lock 4, but it was moved to lower the canal beneath the new Manchester & Bolton Railway in the 1830s. The lock was later made into a 34-yard tunnel, but it has now been opened out.

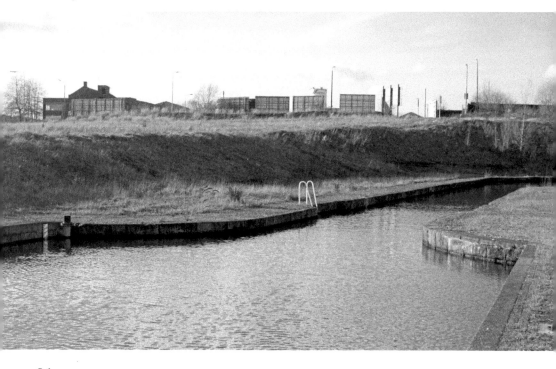

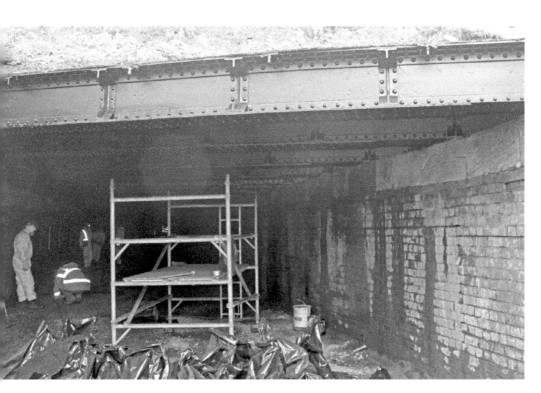

Salford Tunnel No. 2
The tunnel, which is 49 yards long, is at the end of the restored Middlewood length. Network Rail did not realise that there was a tunnel here beneath their tracks. These pictures were taken when the tunnel was refurbished in 2012. The canal bed is thought to be intact, though filled with stone. The tunnel is no longer accessible.

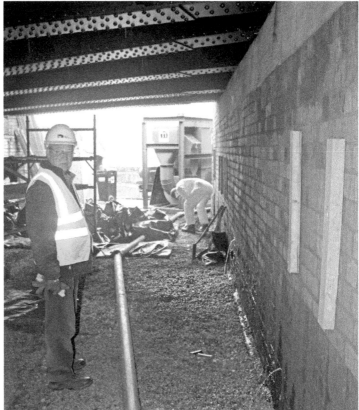

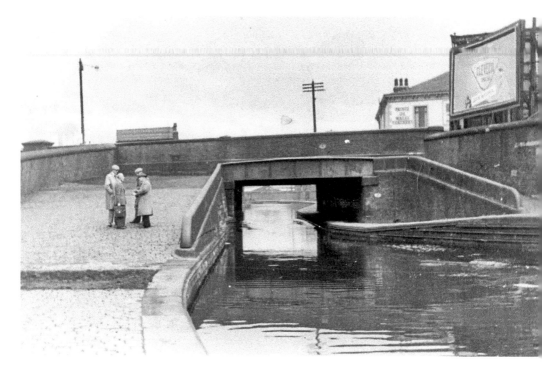

Windsor Bridge

Windsor Bridge was both a road and a canal towpath bridge. The latter was a roving bridge, taking the towpath across the canal, turning through 360 degrees, allowing a horse pulling a boat to remain hitched. The upper picture was taken in 1954; the lower picture shows the canal being infilled in the 1960s – Salford's flats have arrived.

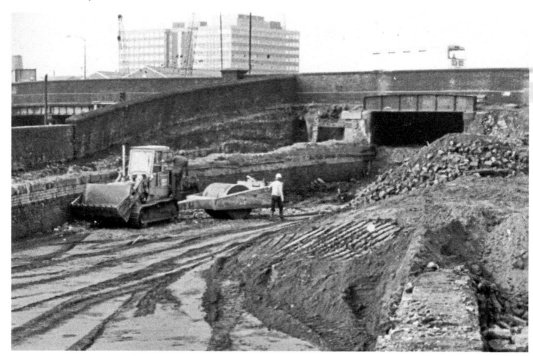

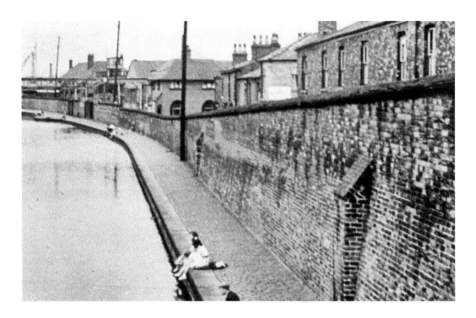

Windsor Bridge

The upper view from Windsor Bridge is now unrecognisable. The lower view is taken from a similar spot, just outside the new booking hall of Salford Crescent station. When restored, the canal will pass beneath the booking hall and go along the line of the earth bank between the railway track and the road.

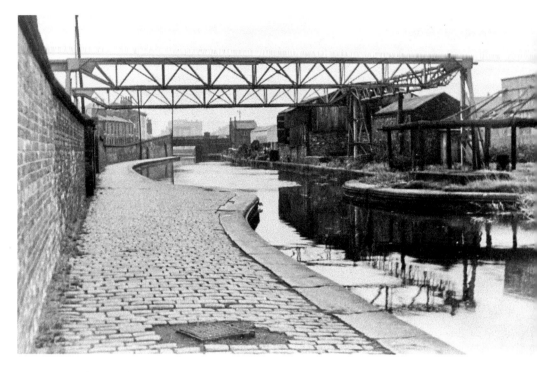

Windsor Bridge and Pendleton

The upper picture is looking back towards Windsor Bridge, with a travelling crane and narrows for inserting stop planks to allow the canal to be drained. The lower picture is just beyond Frederick Road Bridge, with Orient, Worsley and Bank Mills in the background between the canal and Lissadel Street.

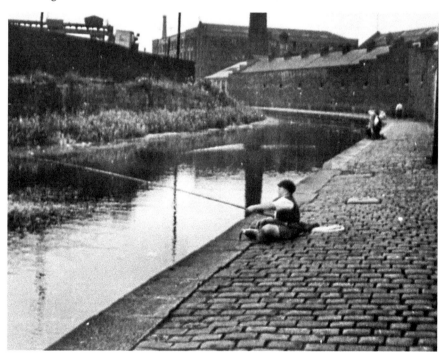

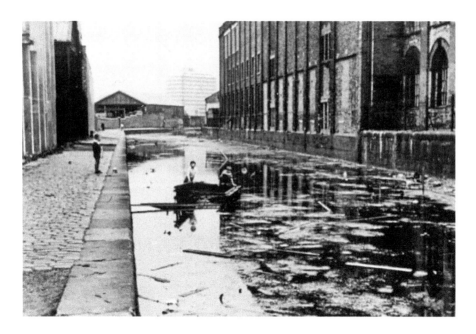

Pendleton

Taken in 1966, the upper picture shows the canal passing the former power station; a timber yard and the tower block of Salford University can be seen in the distance. The canal is now covered by a car park and a builders' merchant's shed, but the buildings on the right are still recognisable. The main building was Salford's electricity generating station.

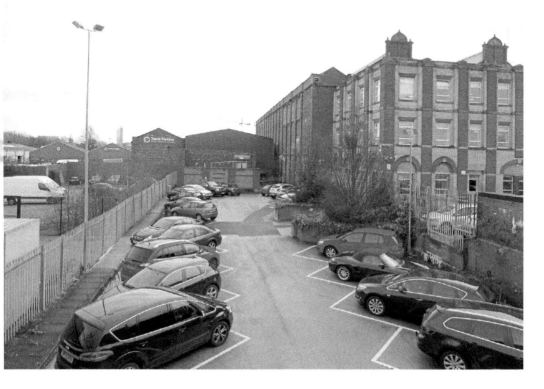

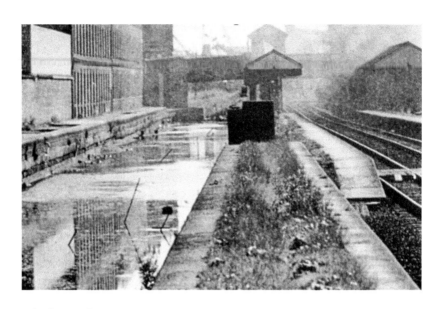

Brindle Heath

The upper picture, showing the old Pendleton station, shows the canal and railway running closely alongside each other. The lower picture is looking in the opposite direction from Broughton Road Bridge; the station has gone, and the line of the canal is to the right of the fence.

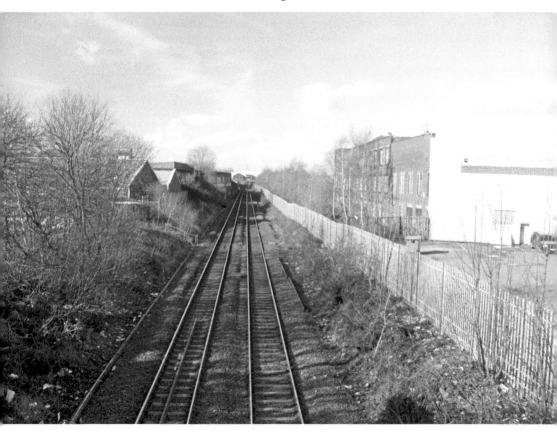

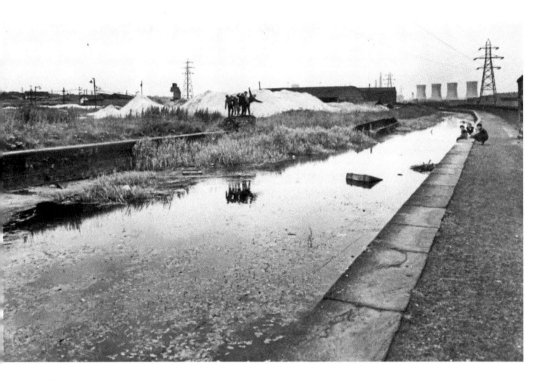

Indigo Street

Two views close to Indigo Street; a short stub of the street still remains off Langley Road. The Manchester Oxide Company processed spent iron oxide in a plant on the opposite bank. The lower picture shows the canal towpath removed to allow access to the tarmac yard. The entrance is gated and locked, and access is not usually possible.

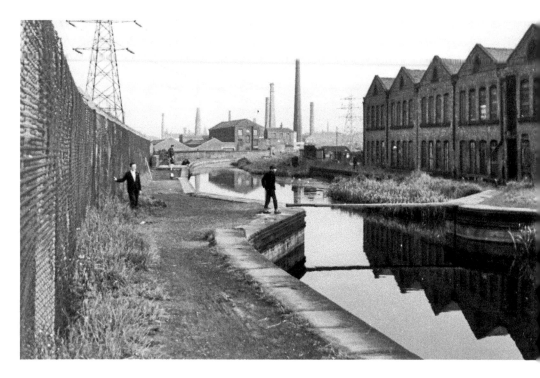

Agecroft Hall Paper Works

Two old pictures of the same site, looking south (*above*) and north (*below*). A plank spans the point where the canal was narrowed to enable stop planks to be inserted to drain the canal for repairs. In the lower picture, three children are sitting on the plank. The paper mill on the opposite bank was established in the 1870s by William Chadwick. It closed in 1925.

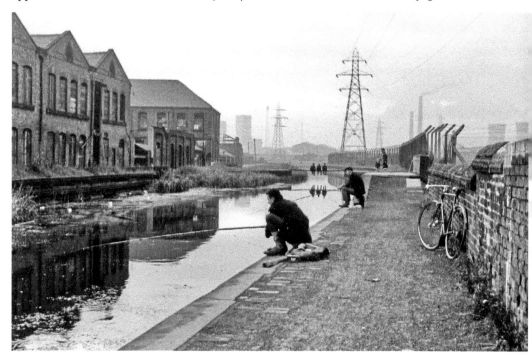

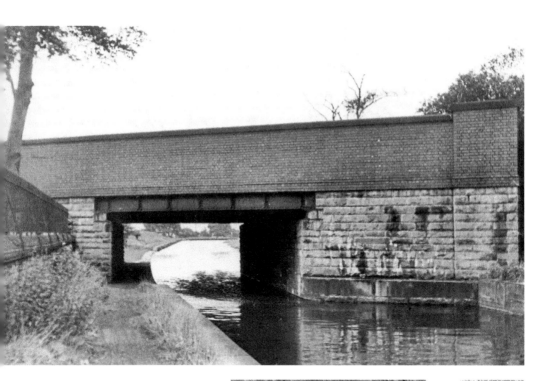

Agecroft Road Bridge

The upper picture shows the bridge before its rebuilding in 1990. On the left-hand wall, just beyond the bridge, is milestone 3, which had been damaged by frost; it was repaired by the Manchester Bolton & Bury Canal Society in 2011, with advice from a local monumental mason. The canal has over thirty quarter-milestones still in place.

The companion volume, *Manchester Bolton & Bury Canal Through Time*, has forty-four images of the canal in Salford (almost all different to those here), plus nine of the Middlewood restoration in 2008. In total, the book has 186 images of the canal. To follow the rather difficult route of much of the canal in Salford (as well as the rest of the canal), the *Towpath Guide 2* (revised in 2013) is available from the Canal Society (www.mbbcs.org.uk).

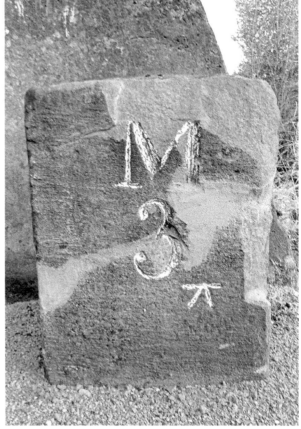

Further Reading

Bergin, T., D. N. Pearce and S. Shaw, *Salford: A City and its Past* (1975) [this has a detailed chronology up to 1974]

Cooper, G., *Salford: An Illustrated History* (2005)

Gray, E., *Salford (Britain in Old Photographs)* (1995)

Hayes, C., *The Changing Face of Salford* (2003)

Hindle, P., *Manchester Bolton & Bury Canal Through Time* (2013)

Tomlinson, V. I., *Salford: An Outline of the Growth of an Industrial Town in Pictures* (1974)

Maps

Alan Godfrey Maps (www.alangodfreymaps.co.uk) publish printed versions of Ordnance Survey 25-inch maps (1889–1931). For this book, the sheets needed are: Broughton, Cheetham, Eccles, Manchester North West, Manchester South West, Pendleton, Rainsough and Salford West. They also publish some of the 5-foot plans (1848/49) for central Salford: sheets 22, 23, 27 and 28.

 The Digital Archives Association (www.digitalarchives.co.uk) publishes the full set of Lancashire 25-inch and Manchester & Salford 5-foot plans on DVD.

Acknowledgements

Many thanks are due to Duncan McCormick, librarian at Salford Local History Library, who was unfailingly helpful.

 Photograph credits: Salford Local History Library, Manchester Bolton & Bury Canal Society Archive, Paul Hindle.

 Ordnance Survey map credits: Alan Godfrey Maps.